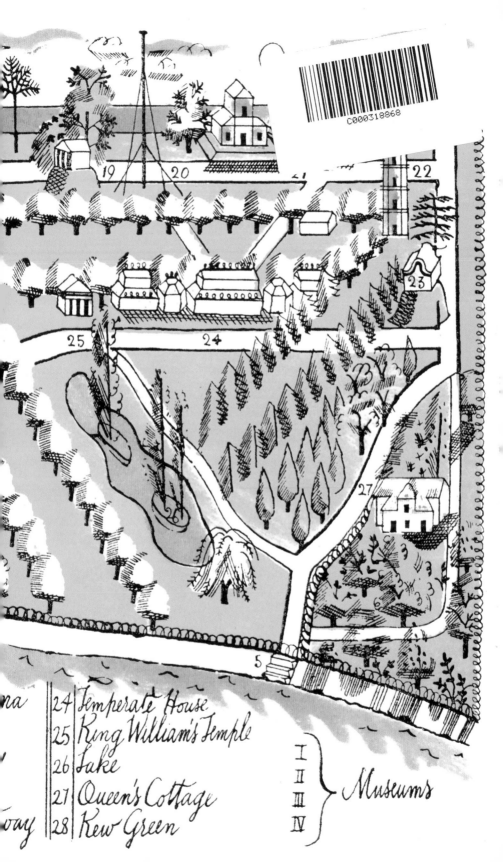

19
20
21
22
23
25
24
27
5

I
II
III
IV
} Museums

EDWARD BAWDEN'S
KEW GARDENS

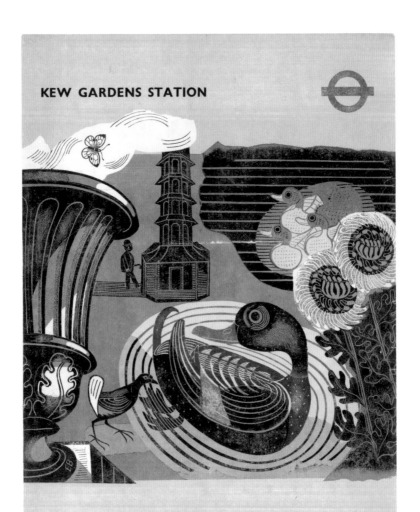

KEW GARDENS STATION

OPEN DAILY, ADMISSION 1ᴅ
TUESDAYS & FRIDAYS (STUDENTS DAYS) 6ᴅ

KEW GARDENS

EDWARD BAWDEN'S
KEW GARDENS

PEYTON SKIPWITH & BRIAN WEBB

V&A PUBLISHING
In association with
ROYAL BOTANIC GARDENS, KEW

1938 ANNE 2012

First published by V&A Publishing, 2014
Victoria and Albert Museum
South Kensington
London SW7 2RL
www.vandabooks.com

Distributed in North America by Harry N. Abrams Inc., New York

Hardback edition
ISBN 978 1 85177 779 2

Library of Congress Control Number 2013945522

10 9 8 7 6 5 4 3 2 1
2018 2017 2016 2015 2014

A catalogue record for this book is available from the British Library.

Jacket front: *Kew Gardens*, poster, London Transport, 1939.
Jacket back: The Pagoda, Kew, from *The English Scene*, 1953.
Endpapers from *Adam and Evelyn at Kew*, 1930.
Frontispiece: *Kew Gardens*, poster, London Transport, 1936.
Line drawings throughout the text from *The Gardener's Diary*, 1937.
Chapter headings pp.7, 33 and 91 from *Adam and Evelyn at Kew*, 1930.

All images are by Edward Bawden unless otherwise stated.
© Edward Bawden Estate

Designers: Webb & Webb Design Limited
Copy-editor: Lesley Levene

Printed in China

V&A Publishing
Supporting the world's leading
museum of art and design,
the Victoria and Albert
Museum, London

CONTENTS

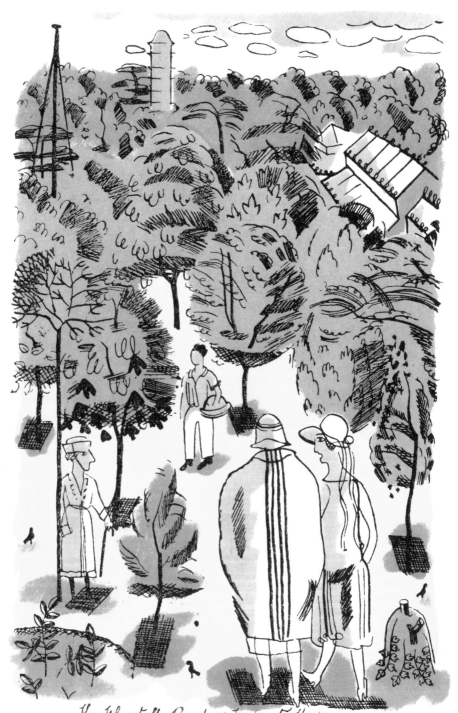

The Flagstaff, Pagoda & Temperate House

PREFACE

*T*he idea for this book grew from the authors' shared desire to reproduce in some form or other Edward Bawden's early manuscript *A General Guide to the Royal Botanic Gardens Kew, Spring & Easter 1923*. The problem was how to do it. The manuscript is contained between battered cardboard covers, bound with string, and the text, as with most dummies, is unconnected columns of upside-down print. To make a facsimile without explanation would be pointless. The idea of a boxed edition containing a facsimile and explanatory text was discussed and dismissed. Having already published our 2011 *Edward Bawden's London*, Mark Eastment at V&A Publishing expressed great enthusiasm for the project and we embarked on detailed discussions for an appropriate format. Should it just be the original 1923 *General Guide* accompanied by a contemporary text, or should it include Bawden's illustrations for *Adam and Evelyn at Kew*, many of which are prefigured in the earlier manuscript?

Robert Herring's text for *Adam and Evelyn* contains a gloriously garbled history of Hanoverian England for which Bawden drew, or redrew, vignettes of George III, Queen Charlotte and Sir William Chambers, thus making the history and development of Kew Gardens integral to the story of

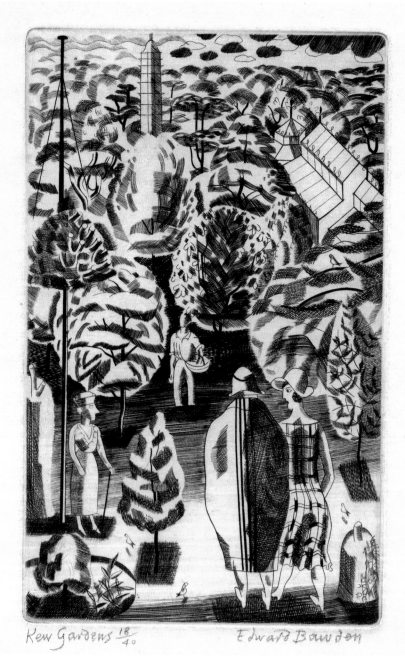

Kew Gardens, *copper engraving, 1927–9.*

Edward Bawden's Kew. This posed another problem: the first half of the book would be concerned with the social evolution of Kew, to the frustration of those readers eager to learn about Bawden's involvement with the Royal Botanic Gardens.

The design of the book presented its own problems. Bawden's *General Guide*, inscribed 'My first book' and given to Eric Ravilious, needed to be depicted as a unit, and as it was the inspiration for this volume we decided to print it in its entirety at the outset, with explanations and history to follow. Equally, the illustrations to *Adam and Evelyn* made little sense if split and distributed throughout the text, so they appear, again in their entirety, between the history and Bawden's abiding interest in Kew, which stretched over 60 years from the 1920s to the 1980s. The earlier history of Kew and the large cast of characters who inhabited and helped to create it are illustrated, with often scurrilous and witty cartoons and caricatures as well as a couple of the richly diverse range of botanical illustrations for which Kew is famous.

While researching and writing the text, as well as researching illustrations, many friends, colleagues and institutions have been consulted and the authors would particularly like to thank Elizabeth Gilbert and Carol Westaway (RHS Lindley Library), Julia Buckley, Kiri Ross Jones and Lynn Parker (Kew Archive), Ella Ravilious (Victoria and Albert Museum), Tom Perrett and Victoria Partridge (The Higgins, Bedford), Karen Taylor (Towner, Eastbourne), Guy Schooling (Sworders, Essex) and the staffs of the London Library and Tate Archive. Nicolas Barker, Richard and Joanna Bawden, Elisabeth Bulkeley, Gill Clarke, Andrew Edmunds, Mary Greensted, Antony and Mary Haynes, Lord Irvine of Lairg, John Russell-Taylor and Dot Thompson have all contributed in one way or another. Particular thanks are due to Mark Eastment of V&A Publishing for his enthusiasm for the project and Lesley Levene for her ever-careful editing.

to Eric Ravilious my first book

A GENERAL GUIDE
TO THE ROYAL
BOTANIC
GARDENS
KEW
SPRING
& EASTER 1923

Edward Bawden

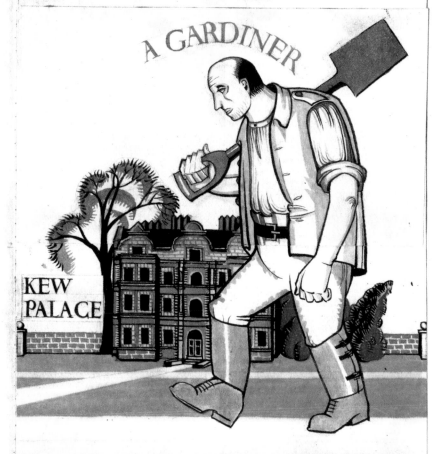

le, the hermit of Hampole, near the 14th century. The translatic Latin text, verse by verse, the ger hand, and the translation g rk was originally written in the s popular all over the kingdom, an present one) the dialect is sout . 158.]

PSALTER AND CANTICLES, in *Lat* bably in the West Midlands, abor tury. The same MS. contains the Shoreham, vicar of Chart Sutton, the Psalter is not Kentish. The] in, verse by verse. Only one othe *ld. MS.* 17376.]

THE BIBLE, in *English*, of the posed to have been prepared abou erents, under the direction, and p Wycliffe himself. This version, in Vulgate, not from the origina first complete Bible in the Englis y was written towards the end onged to Thomas of Woodstock, D of Edward III., who was put to de 1397. With fine illuminated ir glish style. Vellum. [*Egerton 1*

THE NEW TESTAMENT, in *Englisl* sion, a revision of the earlier on h century, perhaps by John P owers. This copy was written i ted to Queen Elizabeth as a New Y of her chaplains. Vellum. [*Ro*

THE PSALTER, in *English*, of the la Canticles and Athanasian Creed. *ld. MS.* 10046.]

THE CATHOLIC EPISTLES AND APO r Wycliffite version. 15th centu

Myopolis, who was engaged for t ished it in March, A. D. 1111. V THE FOUR GOSPELS, in *Syriac*, of th own, from the discoverer of this spels." The MS. was acquired (frc ipara in the Nitrian Desert in E ly known MS. of this version un palimpsest in the monastery of S ntains the same version in a some rm. 5th century. Vellum. [*A*

THE PENTATEUCH, in *Syriac*, of shitto. This translation of the e authorized version of the Syr en made about the 2nd century; t the New Testament, which supers s probably made by Bishop R e 5th century. The present MS. (eceding one) was written in A.D. rliest extant copies of the Peshitto ble in any language of which the e palimpsest *Add. MS.* 14512, w riting the greater part of the Pesl D. 460. Vellum. [*Add. MS.* 144

THE APOCALYPSE, in *Coptic*, of the alect; imperfect. Written in a s the 5th century, on pages meast e of the earliest extant represe ellum. [*Oriental MS.* 3518.]

THE GOSPEL OF ST. JOHN, in *Gre* gyptian dialect; imperfect. A i iblical text, which is the earlier, i rallel columns, written in a larg e 6th century. The later writii bles and problems. Vellum. [*O*

THE EPISTLES AND ACTS, in *Copti* gyptian dialect, with *Arabic* tr ritten in 1308, being copied fro

A RAINBOW

though the colouring and details | ery and the landscape backgrou

see nos. 82, 119. The latter M | ure-initials and borders, the lat

Italo-Byzantine manner, probabl | ork, with birds, gold studs, etc.,

typical late 13th–early 14th centu | one case on a broad gold grou

a more ornate style, with the | or Marcello of Venice (?), on the fi

prominent a feature of Italian

There are hints of the influence | , in *Latin*; end of the 15th centu

though somewhat crowded, min | several services, and full bord

pleasing ones of no. 85, and in | richly coloured grounds, with sm

the Prato MS. (no. 120). The co | norini, etc., interspersed. Execut

volume are adorned with delica | ed Smeralda or Esmeralda. Arn

a characteristic device, which is | ief *argent* a cross of the field. [A

in no. 86, and is elaborated into a

in no. 122, one of the great choir | acedonian War, with the Epitome

Italian illumination is ensl | dle of the 15th century. A typi

viz. a fine Sienese | the first page of text is a full bor

and full b | filigree pen-work, with medalli

of Calabria and Aragon quarter

the *siège périlleux* and open bo

on and I. of Naples (d. 1458

il pattern. [*Harley M*

blue, and green, and covered with [...] colours (no. 100). All these style[s ...] artists availing themselves of t[he ...] renaissance and adding graceful [...] medallions with portrait busts an[d ...] fawns, sphinxes, etc., and wonderf[ul ...] other jewels. Of the many local s[...] [...] half of the 15th century, the [...] [...] and it is one in whic[h ...] [...] the examples [...]

no. 105). All these [...] versatility of Italian a[...] illumination, as in oth[er ...] succeeding age, the [...] finished works of art[...] invention, richness, an[d ...] is formed of twining v[...] grounds (Saloon, Case [...] both in borders and in [...] like the calligraphic s[...] occurs, of the style cu[...] [...] C, no. 10[...]

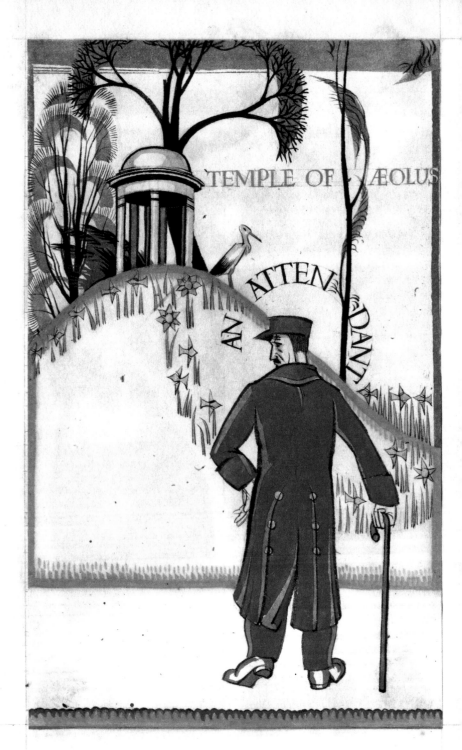

nostly in grisaille, with borders
on a white ground, in Franco-Fl
0. 1.]
4. History of Godfrey de Bouil
French ; late 15th century. A fir
court, with buildings and landsc:
and gilt scrolls on a dark-grey gro
of England, perhaps painted in lat
5. Le Livre des propriétez des
Corbechon from the Latin of Bart
at Bruges by Jehan du Ries in 14
of flowers, birds, etc., on a dark
i, iii.]
6. Boccaccio, De casibus virorur
French by Laurent de Premierfait
ently executed, doubtless at Br
large and many small miniatures.
arms of England with Yorkist bad
7. La Forteresse de la Foi, a tran:
Richart dit l'Oiselet of a Latin
and Jews by Alphonsus de Spina
du Quesne, late 15th century.
borders of flowers, scrolls, and gro
grounds. [*Royal MSS.* 17 F. vi, v
8. Psalter and Antiphoner, in *L*
Weert, of Louvain, for Tongerloo
Miniatures, initials, and borders o
on coloured grounds. [*Add. MSS*
9. Bible, in *Latin* ; written in Ita
14th century. Fine miniature
grounds, with borders of slende
in sweeping scrolls of conventic
initials in Genesis and St. Matt
Creation and a Tree of Jesse, sp
MS. 18720.]
0. Address, in *Latin* verse, to Rob
from the town of Prato in Tusc:
under his protection ; about 1335

form, in gold. A miniature, on a
king, between the Virgin and St.
the Saviour, who is seated within a
with a border of coloured foliage on
MS. Vespasian A. viii.]
Psalter, in *Latin* ; written at
time of Bishop Æthelwold [963–9
the Crucifixion is an exceptiona.
figure-drawing, and the large orna
served as a model for the initial in
Conquest. [*Harley MS.* 2904.]
Gospels, in *Latin* ; written at
early 11th century. Miniatures
initials and borders in gold, silver
of each Gospel. [*Add. MS.* 3489
Gospels, in *Latin ;* early 11th
for Christ Church, Canterbury, c
a charter of King Cnut confirming
borders in Winchester style. [*R*
, "Psychomachia," by Aurelius
the conflict between virtues and
century. Outline drawings in
descriptions in *English.* One of th
copies of this poem. The pages sh
away his bow and arrows and Por
plunging barefoot into thorns, an
abstaining from spoils. [*Cotton M*
, Offices of the Holy Cross and T
etc., in *Latin* and *English* ; wr
1012–1020, partly by the monk
1035. Two outline drawings, ti
the other (exhibited) of the Fat
Virgin standing on their right,
arms and the Holy Spirit as a dove
are Satan, Judas, and Arius the
open jaws of Hell. [*Cotton MS.*
, Register and martyrology of
English ; written about 1016–102(

BRIEF ★★★ HISTORIC ★★★ NOTES

olour, as compared with the Book
raits of the Evangelists are plain
models, which there are grounds for
o Lindisfarne by Hadrian, abbot
llumination in its decadence m
Gospels, A. D. 1138, and a 12th-1
xhibited in the Saloon (Case D, n
 We come now to English illu
rom the 10th to the 15th centuries
arlier work, in the 7th and 8th
rish tradition, sometimes with
ther sources, as we saw in the case
more striking example of mixed s
f St. Augustine's, Canterbury (S
nitials in this MS. are in the m
ntricate in design and plentifully
ne miniature, David among his
omposition, and is framed in an
vith Roman details of ornamen
owever, like the Bede exhibited
nitials which hardly differ at all fr
MSS. The evolution of a definite
f these different influences was
nd a new style, founded on cont
0th century; crudely at first,
Athelstan's Psalter (Cotton MS.
eveloping into the well-marked
ssociated with the Winchester sch
e said to have begun with the ap
Bishop of Winchester in 963, hel
llumination down to the Norman
vith other schools for at least a c
amous productions are the Bened
84) in the Duke of Devonshire's
Missal (late 10th and early 11th cen
hree-volume Bible (second half of
reserved in the Chapter Librar

eat care, at first only by means o
rwards by gradations of colour too
er portions of the figure are merely
e plain vellum, while the draperies
re painted in full body-colour (se
f the pendent border may be traced
prolongation of the historiated of
af or knob, to the cusped bar which
ree, or sometimes all four sides
l, or grotesque figures, and putting
. 21, 26-8, 103). The smaller
egin also to be adorned with per
great part of the margin with an
great delicacy (see nos. 20, 21, 26)
a distinct feature of English 13th
more fully developed afterwards in
d into the 15th century. Through
h century there was no essentia
French MSS. This is very notice
Latin Bible which have survived
gh not invariably, of diminutive
d on the same plan, with Creation
, a Jesse-tree in that of Matthew
ps in the other initials (see nos. 20
, 2; also Saloon, Case C, no. 95
19, 20). Though Bibles are the
ated MSS. of this period, the fines
lters. In these, besides an illus
nitials to the psalms, with specially
s at the principal divisions, there
ntings of the Life of Christ; and
ried far beyond this range, notably
as Queen Mary's Psalter (Roya
-century art appears in its fulles
xceptional wealth of illumination
scinating book has on almost every
ings of extraordinary delicacy and

PRINCE FREDERICK RETIRES TO KEW

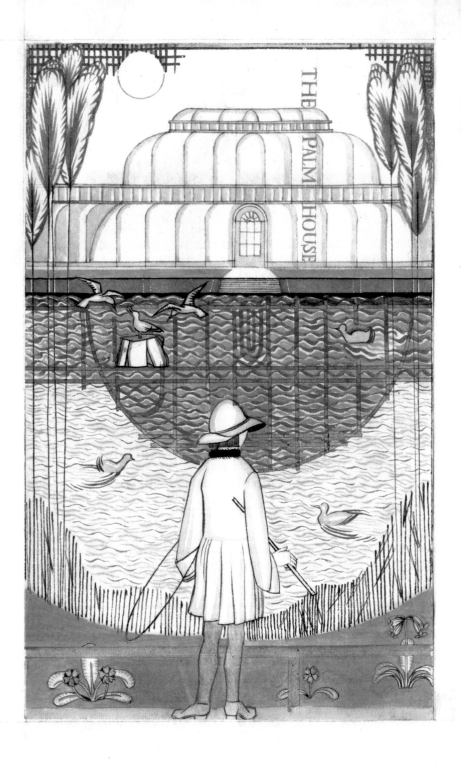

us or serf and all his issue, ...
e a hawk " ("et pro hac donacione
ccipitrem). Witnesses: Sir Peter
lw. I.] *Latin.* With seal. [Add
of Queen Philippa [wife of Edwar
ter of St. Paul's, London, desiring
ert de Chikewell, her Chancellor,
Idesworth, canon of St. Paul's, of
ch he is otherwise unwilling to
ts. Dated at Antwerp, 16 July, 1
[Harley Ch. 43 E. 10.]
of Edward, Prince of Wales, etc.
etters of his father EDWARD II
360, whereby the term for the fulf
of the articles of the Peace of
haelmas to All Saints' day [1 N
consecrated body of Christ to
Boulogne, 31 Oct. [1360]. *French.*
.]
of Abbot Peter and the conver
dmitting to the privileges of conf
d Sir Robert Corbet his son, a
living or dead; the two knights u

t to the Abbey an acre of land
urch in Eberton [Ebrington, c
he Conversion of St. Paul [25 Jan.
of arms of Robert Corbet. [Har
t by William de Wyndesore w
war for one year under Thomas
ngham, Constable of England, in
and France, with a retinue of 200
the said William to find 100 men
at his own cost (save an allow
of the King's grant to him o
wife [Alice Perrers, mistress of
rst Parliament, and the other
himself, one other banneret, 2
res. Dated at Westminster, 10 M
With fragment of the King's
]
certificate of the process by w
Tilbury church, co. Essex, by Will
n College, co. Kent, to which it h
escribing how he laid hold of the d
entered the church, proceeded to
he chalice, vestments, books, etc

[Harley Ch. 48 C. 31.]
in de Chaworth and Robert Tybe
Ienry III., in the Holy Land with
1,200 marks and their passage, *i. e.*
hemselves, their servants, and t
nster, 20 July, 54 Hen. III. [127
d. Ch. 19829.]
m Edward, son of Henry III.,
hop of York, and others, to rais
5,000 marks lent to him by diver
of the Knights Hospitallers at Ac
e may not perish and access to
to him ("ut fama nostra non de
penes alios precludatur "). Date
II. [1272]. *Latin.* With seal.

Henry de Lascy, Earl of " Ni
le of Chester, etc., to Bernecestre
by Sir Gilbert Basset and Sir Will
for three teams of oxen, fuel-w
necestre, and a mill with suit of t

he witnesses were assembled, no
s marriage with Eleanor, the Kin
e royal seal, in lead. [*Add. Ch.* 24
ation by S[imon] de Montfort, Earl
, Geoffrey and Guy de Lusignan,
ceptance, as English plenipotenti
th France. Dated at Paris, 1 Ju
Latin. [*Add. Ch.* 11297.]
of HENRY III. appointing Humph
l and Essex, Constable of Engla
, Earl of Albemarle, his procurat
his own presence ("ad iurandum i
a nostra") that he will keep th
ade at Paris. Dated at Westmin
Latin. With seal. [*Add. Ch.* 1
ant by Eleanor, Queen of Henry
Spinellus Symonetti and his fell
to indemnify them in the matte
n which the name of Walter de M
without his seal being attached.
1262. *Latin.* With fragments

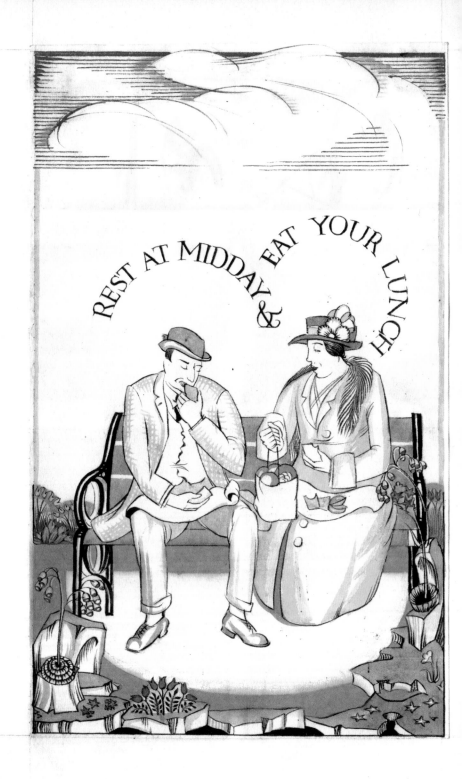

ay be connected with the hand of
origin Merovingian, was gradually
f the Caroline minuscule.

The hand seen in the charters of
ssentials not very different from
hough more so than was the case w
ings. There is usually a tenden
entional forms, exaggerated flouris
an in a book hand; and the main
d book hand of the century follo
e flourishes of the former and it
ere many varieties of the charter
ecimens exhibited will show. Tl
ith its large a's and lengthened f's
om the book hand than no. 8 just
Though it ran to some extent
arter hand was less independent
reek cursive of the uncial. Th
tween the two, many less elaborate
ry similar to that of charters, an
fluenced by the development of
me general characteristics appear.
ntury we get for the most part the

the contemporary book hand; in
actness and a reduction in size cl
th century it becomes less regula
e end of the 14th, and in the 1
inted, angular character of the bo
In the 12th-century charters it
e often much lengthened, being
ose not so lengthened are frequ
ntemporary book hand (above,
roke of the fork was lengthened, u
sort of ornamental spur some dist
roke. Good examples of this pr
D. 1189). In the 13th century
e and delicate hand of great
D. 1230) is a beautiful example.
t only have the upstrokes the f
rther decorated on the left side wi
e the teeth of a saw; and the ri
olonged upwards but turned back
D. 1235) the loop is still more
D. 1243) and later charters it ha
e hand. As the century advance

SUCCULENT HOUSE

that land shall give 2 sh., and wl
, it shall give 16d., etc. Witness
e Countess, Hervicus his brother,
tin. [Cotton MS. Nero C. iii. f. 22
n Ranulph [de Gernons], Earl
Beaumont], Earl of Leicester,
f the castle of Mount Sorrel, co. Le
e demolition of the castle of Rave
in presence of "the second" Rol
Lincoln, and adherents of the t
atin. [Cotton MS. Nero C. iii. f. 17

Henry I, son of Will. I.], and others
ppy, with a genuine seal. Deposi
hich also possesses the original. In
esses are autograph.
Charter of Anselm, Archbishop of
cclesie"), restoring to the monks
hurch, Canterbury] the moiety of
e had after the death of Lanfran
estored the other moiety; and at
anor of Stistede [Stisted, co. E
elong to them. Witnesses: Wil

CONSERVATORY

[THE CLERKS' HOLIDAY]

at in the MS. (no. 1) exhibited both
When we pass from the Hebrew to
al with both the Old and the Ne
eek translation of the Old Testam
s come down to us as a whole, is th
e name (Lat. *septuaginta*, "seventy
at the translation of the Pentateuch
olemy Philadelphus (285–247 B. C.)
o translators, six from each of th
ms to preserve the historical fac
nslated at Alexandria during the
ining books were added later by va
rk was in existence by the 1st cen
addition to the canonical Scriptu
ne of which were translated from
re composed in Greek at the firs
ame the usual Bible of the Jews o
e international language in the Eas
e Christians in their polemics and
ndard Hebrew text established ear
w translations were successively
ntury, those of Aquila, Theodotion,

isita near Naples, who had come
arsus, Archbishop of Canterbury,
e country, and there is evidence
ith him a MS. of the Bible from v
nglish Vulgate Bibles (or some of the
o doubt including Vulgate Bibles,
enedict Biscop, Abbot of Wearmou
e Vulgate, the Codex Amiatinus, n
ngland at Wearmouth or Jarrow, an
Rome in 716 as a present to Pope
her Bibles written at the same tim
eserved in the British Museum; a fa
se H (in Wall-frame 14). Other e
dition are nos. 13 and 15. No. 18
superb example of English illumina
pplies the evidence referred to above
xt from Italy to England by Abbot
lessons for festivals, etc., which fo
urch of Naples.
Towards the end of the 8th centur
ving established his power, set him
g education and reviving learning
vited the Englishman Alcuin to se

THE BEGONIA HOUSE

e Old Latin was translated, and wh
hows considerable divergences fro
erome's own day. He therefore re
on of the Old Testament, direct
heme he carried into effect, neglec
xcept Judith and Tobit), which he
Jerome's translation and revision
ut was at last universally adopted
e Old Latin version now survives
erome's version that the name "Vul
anslation of the Psalms failed, ho
vision, known as the Gallican vers
stinct elements in the Vulgate: (
e Greek (Apocrypha except Judit
vised by Jerome (Gallican Psa
) Jerome's translation from the He
Just as many variations had been
ld Latin version by successive ge
ulgate text in turn became corru
rruption reached its greatest heigh
adition was preserved, and from
ngland, probably in the 7th centu
its near Naples who had some

ese has survived except in fragmen
Daniel superseded the original S
ich is found in only one extant MS
In the first half of the 3rd century
the Septuagint with a view to ge
ween it and the current Hebrew te
different texts in parallel colum
brew in Greek letters, (3) Aquila's
nslation, (5) the Septuagint, revised
nslation. To this famous text
sixfold") was given; it enjoyed a
ote in the "Codex Sinaiticus" (see
that MS. had been collated with a
m the Hexapla. In the Septuagi
inly from Theodotion's version, s
Hebrew but not in the Septuag
erisk; passages occurring in the
brew he marked with an obelus (
blished Origen's Septuagint text
derings from the other versions
tions were also brought out by
artyred A. D. 311 or 312), and in Eg
MSS here shown (no. 6) represen

SOUTH AFRICA HOUSE

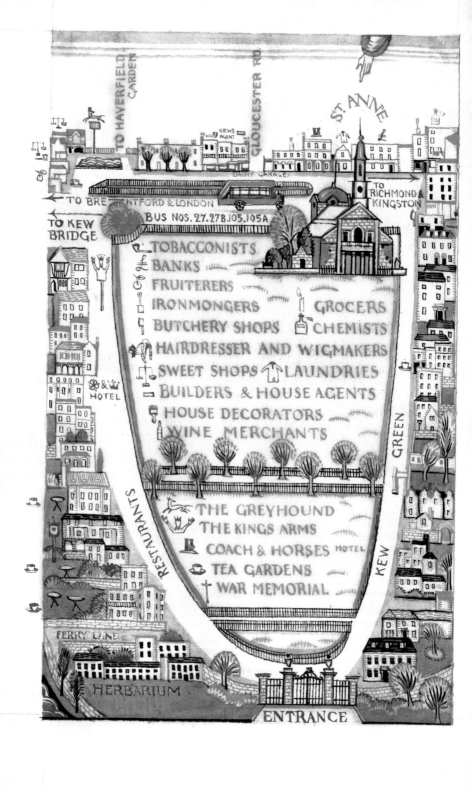

edmon. As stated above in the intr
is probable that his poems have a
e poems which pass under his n
present the character of his work.
ath, Bede (see above, p. 45) transla
other account ch. i–vi only, of St. J
o has perished, as in all probability
lfred is said to have made of the earl
me have identified with this repo
salms 1–50 found in a 10th or 11t
rliest extant Biblical translations ar
en in no. 65 of Case C (9th century)
(10th century) and 21 (10th–11th
nslations are all of the Psalter or
th century marks an advance, in t
rsions were made, such as the Paris
e "West-Saxon Gospels," a MS. of
d about the beginning of the 11th
tion, in abbreviated form, of the I
rtions of the Old Testament, took
After the Norman Conquest there
rther translations (except some met

ed for a long period of time, by th
e square characters is attributed l
t it was no doubt in reality a grad
As will be seen from the descriptic
SS. of the Bible in Hebrew are of mr
eek MSS. But though no Hebrew
dated earlier than the 9th century
SS. show can with certainty be tr
riod. Before the 1st century of c
erable differences in the text of va
nt, as appears from a compariso
th as the Greek Septuagint, wit
e latter seems to have assumed wl
m between the destruction of Jerr
d century. The text seen in all er
marked, is substantially identical r
tury, is known as the Massoretic tex
e school of trained scholars known
dition ") between the 6th and 8th
brew vowels had not been writte
consonantal text they took preca
true pronunciation by introducir

s written about the end of the 11
brought down to the year 1016
several others to 1079. It belong
ed damage in the fire at Ashburnha
copy is exhibited in Case E (no. 13
ited [of which a translation in
Thorpe's edition follows] contai
he invading Danes in 871, includi
red and Alfred at Ashdown, the si
osed to be marked by the well-know
t in the chalk in the Vale of t

e army [i. e. the Danes] came to Readin
ghts after, two jarls rode up, when t
them at Inglefield and there foug
the victory; and one of them was the
Sidroc. Four nights after this ki
rother led a large force to Reading a
and there was great slaughter made (
an Æthelwulf was slain, and the Dan
ttle-place. And four nights after, ki
brother fought with all the army
in two divisions; in one were Bagse

o 1170. This "Romance of Rollo
Normans, in French, and contair
cription of the Battle of Hasting
n who had fought in the battle, ar
details of the fighting.

was written in the 13th centur
ttle Abbey. It contains the secor
the accession of Duke Richard
e selected is part of the account
The following is Sir A. Malet
ught with the kings' division, and the
n; and Ælfred his brother fought agair
ere was the elder jarl Sidroc slain, ar
and Asbiörn jarl and Fræna jarl ar
sions put to flight, and many thousan
ting until night. And fourteen nigh
Ælfred his brother fought against t
e the Danes gained the victory. Ar
thered and Ælfred his brother foug
ton; and they were in two divisior
ht, and far in the day were victoriou
ghter on each side, but the Danes he
ace; and there were bishop Heahmur

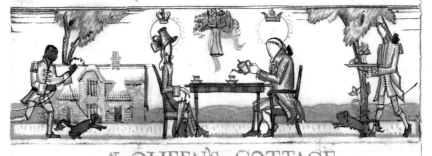

AT THE QUEEN'S COTTAGE

KEW PALACE

rabic and Greek were written in
rabic and Greek. In the case of
ate of this letter official correspond
sed officially for nearly a century
en under Arab rule since A.D.
he conveyance of sailors and wor
ormerly Aphroditopolis), requiring
Egypt, to Basilius, administrato
Official Letter from Said Kurr
: D. 711 or (perhaps more probably

ritten in a large and handsome
erlin. Imperfect, only the co
is class, of the early 8th century,
king the date of Easter each year
5) conceded to the Patriarchs
ace and unity of the Church.
ters, by a theological disquisiti
5 April]; the information being a
forming them of the date of I
Festal Letter from a Patriarch
the Egypt Exploration Fund.
scription. 13 Sept., A.D. 552. [Pa
ritten in a large, upright, cursi
st estates have been discovered
ing at Oxyrhynchus ; numerous
had applied. Flavius Apion
uired for an agricultural machine
ward Menas, by Aurelius Sourous,
Acknowledgement, addressed to
nd. About A.D. 400. [Pap. 722
is liable by hereditary custom.

is returns of somewhat the sa
robably by Augustus (perhaps in
tervals of 14 years was institut
cretary of Theadelphia (in the Fa
pheros, an agricultural laboure
Annual Return, of the nature of
ap. 658.] Presented, in 1896, by
gypt. Written in a rather thick
enches, without interest. From t

s
d at Oxyrhynchus in 1903. A le
ek of a roll previously used to re
incomplete column of a collectio
the 1st or 2nd century. [Pap. 73
ritten in a firm, well-formed u
lums. The part exhibited cont
omplete was a roll of about 16 f
ns of books xiii. and xiv. Foun
ted, in 1909, by the Egypt Explor
ians to Pytho" ; the title is writte
V., "To Delos," and the beginni
han one hand. The portion exhi
lumn shown). Many scholia are a
ed by paragraphs and the mark kn
ely inserted, and there are also cri
es. Accents, breathings, and mar
s now much mutilated, but cont
Domitian, A.D. 81-96) used to re
on the back of a long roll previo

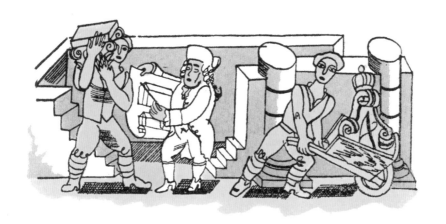

HISTORIC KEW

K ew Gardens and the British Museum are the best places in or near London for a cheap holiday sweetened by communion with the works of nature. Nobody needs to be persuaded that in either of these places the soul should be refreshed, and the mind strengthened in every way consistent with the teaching of the divines, philosophers and moralists. It would be a great advantage if these two places of resort could be adapted to present public requirements. It is very strange however, that while in both cases the rule of the management appears to be to keep the people out to the utmost extent that public opinion will endure, they agree also in compelling all visitors to make a choice between starvation or refreshment at the most uninviting of houses. You may not carry a basket of sandwiches and a bottle of wine or beer into either Kew Gardens or the British Museum and, strange to say the taverns and hotels in the immediate vicinity of each of these places are not so nice as could be wished, considering how fatiguing is admiration, and how thirsty and hungry the body is apt to become while the mind is being fed.[1]

What about packing your bags at once: Isn't it more important to be a professional painter than an amateur gardener?[2]

Edward Bawden was born at Braintree in Essex on 10 March 1903, the son of a like-named Cornish ironmonger and his wife, Eleanor (née Game). It is difficult to be as brief or precise about the origins of Kew Gardens as, like most gardens, it was its fate to undergo constant renovation and change. The Royal Botanic Gardens, Kew, as we know them today are the result of fusion rather than procreation, being 'a palimpsest of successive layouts by professional designers, innovative gardeners and impulsive directors'.[3] The story of the Gardens begins in either 1759 or 1760 depending which authority you choose. However, 1759 was the year the Scots gardener William Aiton was first employed by Princess Augusta, and the year that specific reference to the costs of the Kew 'Physic Garden' first appears in the royal accounts. Wilfrid Blunt, an authority on botanical illustration, historian of Kew and admirer of Edward Bawden, favoured the later date, though he acknowledged that what Blunt referred to as 'the alleged bi-centenary' had been celebrated with considerable pomp in 1959.[4] In addition to an official visit by the Queen and Prince Philip, the bicentennial year provided the impetus for the restoration of the Orangery, which had for some years been used as the Timber Museum, the renovation and reopening of the Palm House, and the planting of a swathe of snowdrops, primroses, narcissi and martagon lilies in the area around the Queen's Cottage. Regardless of whether one supports the official line or sympathizes with Blunt's more perverse preference for 1760, there is no doubting the fact that the foundation of the Gardens preceded Bawden's birth by the best part of 150 years and that the history of gardening at Kew goes back even further.

Wilfrid Blunt, having consulted A.R. Hope Moncrieff's *Kew Gardens* and other histories, began his delightful book *In for a Penny* with the statement that 'It is customary – indeed only proper – to begin a book about Kew Gardens by stating that "Kew" may be spelt in a dozen or more different ways (Kayhoo,

Kai-ho, etc.), most of which look at least as Chinese as its famous Pagoda, and that it may or may not mean "the quay of the howe, or hough" – whatever that may mean.'⁵

Etymologically it actually means, so I am informed, a projecting piece of land. Blunt subtitled his book *A Prospect of Kew Gardens: Their Flora, Fauna and Falballas*, and in its earlier chapters at least it echoes the irreverent spirit of Robert Herring's and Edward Bawden's *Adam and Evelyn at Kew*, so much so that I wish I could reproduce his foreword and claim it as my own. Blunt took the title of his book, *In for a Penny*, from the penny entrance charge introduced in 1916 which continued through pre-decimalization days, when there were 240 pennies in a pound. As with old-fashioned lavatories, the penny was inserted into the slot on a turnstile at the point of entry. Prior to 1916, entrance to the Gardens had been free, and the introduction of the charge during the Great War caused a considerable outcry, with the result that wounded servicemen continued to be admitted gratis. The standard entry charge today is £16.

Bawden was a shy, bookish and introverted young man whose long infatuation with Kew began soon after he enrolled as a student at London's Royal College of Art in 1922. He not only responded to the plants and setting of Kew, but was equally beguiled by the intricate assemblage of people, buildings, romance, frivolity and patronage that had led to the creation of the Gardens. However, before engaging with his many Kew-related images, logic and chronology make it desirable to look back first upon the principal personalities whose vision and ambitions conjured up this Eden on the outskirts of London.

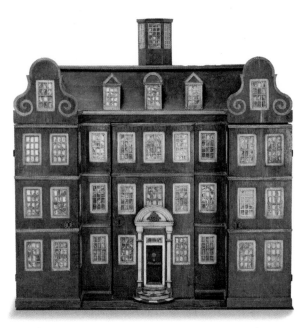

Child's wardrobe in the form of a house, made by
Edmund Joy, oak with paper and glass, 1712.

The story of Kew really begins in 1718 with the arrival at Richmond Lodge of George Augustus, Prince of Wales – the eldest son of King George I – and his wife, Princess Caroline of Ansbach. Bawden's earliest sallies into the Gardens took place two centuries later, during the second decade of the reign of the fifth King George.

Richmond Lodge in the Old Deer Park at Richmond – known for a while as Ormonde Lodge – was an ancient hunting lodge of which the second Duke of Ormonde acquired the lease in 1702. For the next few years he extended and improved the property, but his enjoyment of it was short-lived, as in the wake of the failed Jacobite rising of 1715 he was condemned as a conspirator, impeached and stripped of his lands. These, however, were later restored to his brother, the Earl of Arran, who, benefiting from this unexpected bounty, immediately sold the lease of Richmond Lodge to Prince George, and it was here that the *de facto* prime minister, Sir Robert Walpole,

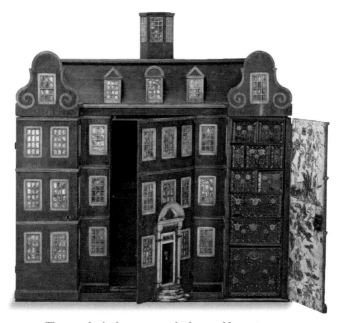

*The wardrobe bears a marked resemblance to
Kew Palace, formerly known as the Dutch House.*

unceremoniously disturbed the Prince's post-prandial siesta
on the afternoon of 14 June 1727 to announce that he was no
longer prince but king, his father having died at Osnaburg
four days earlier. Delighted with this news – love between
the generations of the early Hanoverians being at a premium –
King George II wasted little time exchanging the secluded
life of Kew for the bright lights of London, leaving his consort
to her own pursuits.

Queen Caroline, as she now was, continued to live at
Richmond Lodge, the 'sweet villa' of which she had become
so fond, and over the next few years threw herself with gusto
into a range of projects to improve and beautify the property.
The acquisition of the lease of the Dutch House with 55 acres
of land and a couple of riverside properties with a further 17
acres gave her scope to indulge her passion for landscape
gardening on a grand scale. With the assistance of the two
leading designers of the day, William Kent and Charles

Bridgeman, and her already well-developed eye for the picturesque, she proceeded to unite the properties. Although the Prince had not shared her passion, he had previously looked on his wife's horticultural activities with benign amusement, but now that he had exchanged horticulture for the culture of whores he became indignant at her extravagance. Despite the fact that from the time of his accession she enjoyed an income of £100,000 a year, a formidable sum by any standards, she failed to live within her means and died leaving debts of £20,000. Looking back, it is hard to know which of the two was the most extravagant, the carousing King in Whitehall or the garden-mad Queen at Kew.

Much of the Queen's extravagance was lavished on her Kew properties, where she enjoyed herself remodelling the landscape. She was an amateur of the currently fashionable 'natural school' of which Bridgeman was a pioneer, being among the first to introduce the ha-ha into England. He utilized this cunningly simple device of the sunken wall to divide what is the present Kew Gardens from the Thames as well as from the Old Deer Park, thus creating a seemingly natural landscape which he and Kent then began to embellish with carefully contrived visual surprises – grottoes, temples, a dairy à la Marie Antoinette (with utensils of 'the most beautiful china') and a hermitage, hung in cavalier fashion with Holbein drawings from the Royal Collection, presumably some of those acquired by James I's son Prince Henry from the sale of Lord Lumley's library early in the previous century. Not content with the creation of these follies, she also planted a wood entered by a walk which terminated in the Queen's Pavilion – 'a neat elegant structure with a chimney piece after a design by Paladio'.[6] The King, meanwhile, was enjoying himself in different ways as, according to William Thackeray, he 'claimed and took the royal exemption from doing right which sovereigns assumed'.[7]

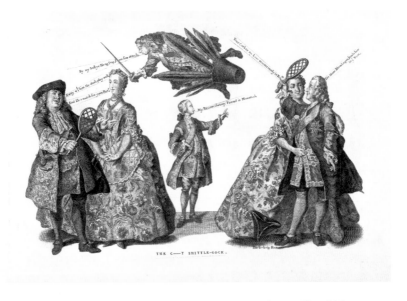

Anonymous, The C[our]t Shittle-Cock, *1740. George II and his mistress, Lady Yarmouth, to the right and Robert Walpole and his daughter to the left play a game of shuttlecock, with the Duke of Argyll flying above the head of Prince Frederick.*

A row between Prince George and his father in 1714 had split the family, making residence at Richmond Lodge, or at least away from London, almost obligatory. Thackeray describes how 'on the occasion of the christening of his second son, a royal row took place, and the prince, shaking his fist in the Duke of Newcastle's face, called him a rogue, and provoked his august father. He and his wife were turned out of St. James's, and their princely children taken from them, by order of the royal head of the family.'[8] From then on the children were largely brought up and educated in Hanover, where George I preferred to live, thus growing up virtual strangers to their parents. By unhappy chance, when George and Caroline's eldest son, Prince Frederick (1707–51), by now Prince of Wales, returned to England in the late 1720s he bought the lease of yet another Kew property, the White House, next door to Richmond Lodge. The two properties were separated only by the inaptly named Love Lane, no love being lost between father and son: to coin a phrase,

they were 'neighbours whose love for one another was as the affection of flint for steel'. Love Lane, running between Richmond and Brentford Ferry, was the ancient bridle-road which had been a much-used public thoroughfare as well as the resort of courting couples until the building of the first Kew Bridge in 1758–9. Part of its path is marked today by the Holly Walk.

Prince Frederick acquired the lease of the White House from Lady Elizabeth St André, the widow of George II's secretary, Samuel Molyneux, an enthusiastic gardener and astronomer who commissioned an observatory complete with Newtonian telescope. The White House grounds had been carefully tended for some years by John Dillman, Molyneux's 'master gardiner', whom the Prince was happy to take on, employing him later at Carlton House as well as at Kew. Molyneux had acquired the property through an earlier marriage to the widow of Sir Henry Capel, another 'ardent cultivator of plants', to whom the late-nineteenth-century Director of the Royal Botanic Gardens, Sir William Thiselton-Dyer, ascribed the 'genesis of Kew as a horticultural, if not botanic, centre'. Having acquired the lease, the Prince employed his mother's architect friend William Kent to modernize the house prior to his marriage to Princess Augusta of Saxe-Gotha in 1737. Kent also designed his royal barge (now in the National Maritime Museum, Greenwich), in which he was wont to have himself rowed up the Thames from Whitehall to view progress and supervise work on both house and grounds.

His enthusiasm for the property was given a fresh fillip in 1749 when he acquired several extra acres to the south, stimulating a bout of planting of 'many curious and forain trees [and] exotics' – the term 'exotics' could equally have

applied to built structures, as, like his mother, he had a passion for architectural embellishment and the creation of follies. Joseph Goupy, his 'Cabinet Painter', whom he consulted on such matters, planned an aqueduct to supply the grounds with water, designed and built a Grecian Pavilion and added the first of Kew's Chinese-style buildings, the House of Confucius, which was later resited by William Chambers. Frederick enjoyed not only discussing such matters with Dillman and Goupy, but also participating in their realization; the pleurisy that was often blamed for his death in March 1751 was brought on by his eagerness to superintend the planting of a new consignment of trees rather than sheltering from the rain. The immediate cause of his death, however, was a burst abscess resulting from a blow to the chest that he had received sometime previously while playing a ball-game at Cliveden, an unfortunate accident which caused Mrs Stuart Wortley to comment wryly that his 'prospects of a throne were defeated by a cricket ball'.[9] If he had only heeded the paternal advice to avoid 'rumling violent exercices', given by James I to his son Prince Henry in the *Basilikon Doron* a century and a half previously, the subsequent history of both Kew and the nation might have been very different. With his death, the lease of the White House passed to Frederick and Caroline's eldest son, the 13-year-old future King George III.

Despite the faults that estranged him from his family, Frederick was a cultivated man with an interest in the arts; he was an accomplished musician as well as an enthusiastic gardener. On learning of his death, the plantsman Peter Collinson noted that 'gardening and planting have lost their best friend and encourager'.[10] While Thackeray asked rhetorically: 'What had Frederick, Prince of Wales, George's

father, done that he was so loathed by George II, and never mentioned by George III?' Rather than answer his own question, he went on to quote a contemporary epitaph:

Here lies Fred,
Who was alive, and is dead.
Had it been his father,
I had much rather.
Had it been his brother,
Still better than another.
Had it been his sister,
No one would have missed her.
Had it been the whole generation,
Still better for the nation.
But since 'tis only Fred,
Who was alive, and is dead,
There's no more to be said.[11]

Posterity has been less censorious. Edward Pearce, in his life of Robert Walpole, points out that Frederick came late to England, having been educated in Hanover from the age of seven, and praises him for having 'tried harder than any member of the family before to adjust sympathetically to all things English'.[12] Following his death, Princess Augusta, with Lord Bute's help, continued the improvements to Richmond Lodge and its grounds which he had begun, including the building of the first hothouse, or 'great Stove' as it was known.

John Stuart, third Earl of Bute, who had originally assisted Prince Frederick, emerges at this point as the *éminence grise* – perhaps *rose* would be more appropriate – behind the creation of the Royal Botanic Gardens, as distinct from the more extensive Kew Gardens. As a young man Bute – pronounced 'boot' in the eighteenth century – had read civil law at the University of Leiden in Holland, a city already

famous as a centre for botanical studies, and it was there that he developed his interests and made the contacts that later enabled him to arrange the importation of exotic plants and trees from Africa, Asia and America to enhance Frederick's gardens and fill Augusta's new hothouse. Bute had entered the royal circle as one of the Prince's favourite gaming partners before being appointed Lord of the Bedchamber in 1750: an appointment that lasted for only a few months due to Prince Frederick's untimely death. On Princess Augusta's insistence, however, after a short hiatus, he was appointed Governor (the male equivalent of a governess) to the young Prince George, becoming not just tutor but, for the next few years, a much-loved companion and virtual father-figure to the future king.

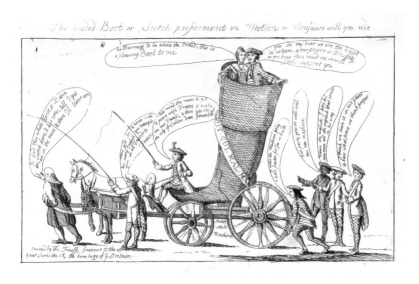

Anonymous, The Loaded Boot or Scotch Preferment in Motion, *1762*.

During those halcyon days of the 1750s, Bute introduced two figures into the lives of Augusta and her son who were to have a major impact on the development of Kew, William Chambers, who was appointed 'Architect to the Dowager Princess of Wales', and William Aiton, who became her 'Gardener'. This trio – Bute, Chambers and Aiton – oversaw

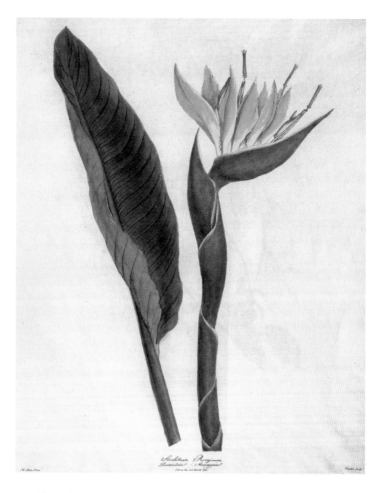

Franz Bauer (1758–1840), Strelitzia Reginae, *1790*. Strelitzia
reginae *was first grown at Kew in 1773 but unfortunately did
not flourish as it was grown in unsuitable tubs or flowerpots.
Sir Joseph Banks had introduced the plant to the British Isles
and named it Strelitzia in honour of Queen Charlotte, who
had been Princess of Mecklenburg-Strelitz.*

the transformation of the Gardens not only architecturally but, more importantly, in terms of research and scholarship, making them the foremost botanical gardens of the world. Chambers's role was wide-ranging, combining the duties of both architect and landscape gardener for the entire site, while the young Aiton, who had first attracted Bute's attention while working at the Chelsea Physic Garden, was put in charge of the nine acres of the botanic garden and arboretum.

In 1756 Bute was appointed Groom of the Stole and four years later, just two days after George III's accession to the throne, created a Privy Councillor, in which capacity he played an important role in arranging the young King's marriage to Princess Charlotte of Mecklenburg-Strelitz. He served as prime minister from May 1762 to April the following year, during which period he brought the Seven Years War to a satisfactory conclusion. This should have been an occasion for national rejoicing, but his friendship with the monarch provoked such bitter jealousy and political rivalry that he was forced to resign. 'The substitution of Grenville for Bute did not enable the King's Government to run more smoothly, but by an obsession that possessed the Opposition and the public, whatever went wrong was the Earl's fault! He was universally believed, like Mephistopheles in "Faust," to be ever at the King's elbow whispering evil councel, and misdirecting the ship of State.'[13] The hostility against him was such that by the time of his resignation he had become the most unpopular man in the country. 'Maligned, insulted, and manhandled wherever he went, he suffered threats of assassination, incurred the wrath of brilliant polemicists such as John Wilkes and Charles Churchill, and was lampooned in over 400 prints and broadsheets. In addition Bute's emblem, the "jackboot", was regularly burned alongside that of his reputed lover, the "pettycoat", Princess Augusta.'[14] Good friend as he had been to Prince Frederick, and continued to be to his widow and son, there is no direct

evidence to support the story of this alleged love affair, though it was a widely circulated story that delighted contemporary gossips, scandalmongers and lampoonists who, among other epithets, dubbed him 'the minister behind the curtain'.

The three-quarters of a century that separates George III's accession from that of his granddaughter Queen Victoria was a period of unprecedented political corruption, chicanery and turmoil, as can readily be seen from the wealth of prints, caricatures and ribald parodies which held society up to public ridicule. Between 1760 and 1768 the country witnessed the appointment and dismissal of five prime ministers, and the Eatanswill by-election as described by Dickens in *The Pickwick Papers*, with the unseemly goings-on of the Buffs and the Blues, is only a mild exaggeration of mid-eighteenth-century political life.

William Chambers had been born in Sweden, the son of an Anglo-Scottish merchant whose business was based in Gothenburg; as a young man he served for a time with the Swedish East India Company, making voyages to both India and China, as well as studying architecture in Paris and Rome. On his second voyage to Canton in 1748 he made a serious study of Chinese architecture and gardens, which brought him to the attention of the Swedish classifier of plants Carl Linnaeus and other influential European figures in the fields of architecture and botany, including the Earl of Bute, and it was through this connection that Chambers, in addition to his duties to Princess Augusta, was appointed Tutor in Architecture to Prince George. The favours that John, third Earl of Bute, showered on Chambers have been

described as 'those of a courtier who was the close confidant of Augusta, and a man learned in the arts, and especially in botany and gardening. Bute is the link between the botanical work of Frederick at Kew and the later work of his widow. He surely conceived the brilliant design for the self-contained Exotic garden with its menagerie, Flower garden and great Stove. On to this Chambers grafted his ornamental pleasure grounds, making an "Eden" out of a "Desert".'[15]

Horace Walpole recorded that Kew being on the flat, 'Lord Bute raised hillocs to diversify the ground, and carried Chambers the Architect thither'.[16] During the next five years, in addition to raising 'hillocs' and converting this unpromisingly featureless site into a bosky landscape, Chambers, under Bute's direction, designed and executed a couple of dozen miscellaneous structures, creating what John Harris has described as 'the first of the World Fairs with their compression of world architecture'.[17] Harris was putting in rather politer language the unattributed contemporary description of Chambers's embellishments as 'unmeaning falballas of Turkish and Chinese chequerwork' – hence the falballas of Blunt's subtitle to *In for a Penny.*[18]

The proximity of the White House to Richmond Lodge, which became King George and Queen Charlotte's favourite summer retreat from 1764 until 1777, gave added impetus to Bute's enemies, who were intent on driving a wedge between him and the young King, urging the latter to assert his independence from Bute's influence and his mother's petticoat rule. It was during the years which had elapsed since Prince Frederick's death that Bute's influence on Kew was at its greatest, and in order to help carry out his plans he

employed, among others, Lancelot 'Capability' Brown and Michael Milliken. It was their combined vision which changed the balance of the royal gardens from a private delight into a 'quasi-national botanic garden of the sort that had never existed in England'.[19] Brown, who was 'master gardener' at nearby Hampton Court, where he lived in the unpropitiously named Wilderness House, was an advocate of sweeping lawns and artistically sited clumps of trees, which led him systematically to dismantle much of Queen Caroline's earlier landscape garden and demolish many of her follies, including Merlin's Cave.

Chambers's designs were published at the King's expense in 1763 as *Plans, Elevations &c, of the Gardens and Buildings at Kew*, a work for which he delineated a wide variety and range of buildings and building styles, provoking one wit to comment that he spent most of his life 'Bute-ifying' the Gardens. Many of these buildings, such as the Mosque, the Gothic Cathedral and the resited House of Confucius, have long since gone. Some were wilfully demolished, others neglected and allowed to decay, and those like the bridge which was erected one night to give Princess Augusta a frisson of pleasure the next morning were never intended to be more than temporary structures. The Temple of the Sun, one of Chambers's prettiest buildings, survived into the twentieth century but was destroyed in March 1916 during a storm which caused considerable damage. A photograph in the *Gardener's Magazine* shows masonry scattered like shards of eggshell porcelain, to accompany a graphic account of the freak blizzard of snow, sleet and wind during which 'the huge Cedar of Lebanon, planted in close proximity, fell across the structure, smashing it down to the stone basework'.[20] Like so many of Chambers's Kew buildings, it had been erected as much for immediate visual effect as for posterity, though few buildings could have withstood the impact of that great tree.

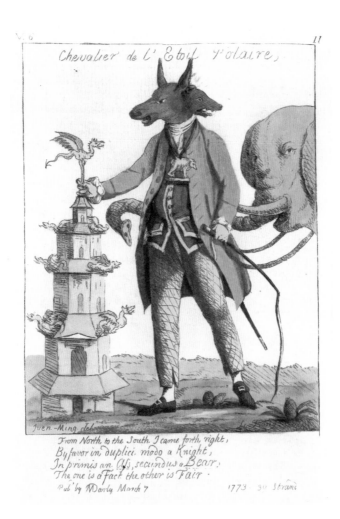

Matthew Darly, Chevalier de l'Etoil Polaire, *1773. William Chambers as a double-headed animal (an ass and a bear) places his right hand on the pinnacle of a pagoda.*

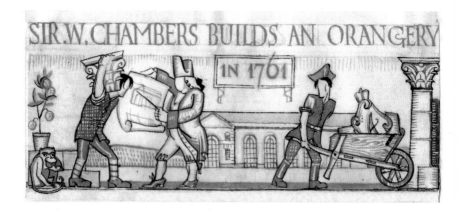

Chambers's most enduring legacies to Kew are the Orangery – or Greenhouse – and the Pagoda, Kew's best-loved building and the 'most ambitious chinoiserie garden structure in Europe'.[21] Beautiful as it still is, the Pagoda is only a shadow of its former self. It was originally adorned with 80 golden dragons with bells suspended from their jaws – 10 at each level – and its multiple roofs glittered with glazed tiles. Sadly these were replaced with slates in the 1780s and, according to Joseph Hooker, Director of the Royal Botanic Gardens from 1865 to 1885, the dragons and bells were removed at the behest of George IV and sold to help pay his gambling debts, though other accounts describe the dragons as being of gilded wood, in which case they would have decayed naturally and the bells would have become redundant. The Orangery, now a restaurant, is not quite the classical stone building it appears at first sight, as it is actually built of brick and faced with Chambers's secret brand of stucco. Bawden's spirited vignette *Sir W. Chambers Builds an Orangery* shows the architect with his plan in one hand, directing a mason to the correct position for the capital he nonchalantly carries on his shoulder, while a knowing-looking monkey, presumably escaped from the menagerie which existed until the beginning of the nineteenth century, sits quietly in the corner devouring a plundered orange. Chambers's Temples of Aeolus and Bellona also survive, but not on their original sites.

Once out of royal favour and away from the public eye, Bute occupied much of his time with the building of houses at Luton and Highcliffe. The latter was a grand villa designed by Robert Adam overlooking the English Channel at Christchurch in Hampshire, where he created his own Botanic Gardens, complete with a 300-foot-long conservatory. His passionate pursuit of plants was to be the unwitting cause of his death. He slipped while trying to reach an unusual plant that he had espied growing on the cliffs, a fall from which he never fully recovered. Despite the opprobrium heaped upon him as a statesman, his reputation among his fellow botanists remained unimpaired: Linnaeus classified two groups of plants in his honour – *stewartii* and *Butea*. W.J. Bean, Curator of the Royal Botanic Gardens in the 1920s, writing a century and a quarter later, noted that 'whatever his virtues or failings as a politician and statesman may have been – and for a short time he was the best hated man in Britain – he was a genuine lover of plants'.[22]

With Princess Augusta's death in 1772 the two properties, Richmond Lodge and the White House, were at last united and George III, who by then wished to replace Bute, looked round for a new director for the Gardens. He appointed Joseph Banks, who had recently returned from his three-year voyage of discovery with Captain Cook on the *Endeavour*. Banks was a wealthy Lincolnshire landowner, botanist and domineering Fellow of the Royal Society who, through the influence of the Earl of Sandwich, had been able to impose himself, along with a retinue of eight, including Daniel Solander of the British Museum, on the long-suffering Captain Cook. The idea for the voyage had been suggested to the King by the Royal Society for the purpose of observing and recording 'the passage of the Planet Venus over the Disc of the Sun', a phenomenon which is said to occur only four times in 243 years and was useful in those days in helping to determine the distance of the sun from the earth. To ensure

the greatest degree of accuracy, it was desirable that such observations should be recorded from a number of prearranged sites, and in order that the King could also witness the event Chambers built an Observatory in the Old Deer Park, the second observatory to be built at Kew and another of Chambers's surviving buildings.

An early membership ticket to the Royal Horticultural Society, blue-stained ivory. The Horticultural Society of London was founded in 1804 by Sir Joseph Banks and John Wedgwood, and renamed the Royal Horticultural Society in 1861. Original members included William Townsend Aiton, son of William Aiton.

At the time the *Endeavour* sailed from Plymouth on 26 August 1768, the naturalist John Ellis wrote to Linnaeus that 'no people ever went to sea better fitted out for the purpose of Natural History. They have got a fine library of Natural History; they have all sorts of machines for catching and preserving insects; all kinds of nets, trawls, drags and hooks for coral fishing, they have even a curious contrivance of a telescope, by which, put into the water, you can see the bottom at a great depth, where it is clear. They have many cases of bottles with ground stoppers of several sizes, to preserve animals in spirits. They have the several sorts of salts to surround the seeds; and wax, both beeswax and that of Myrica; besides there are many people whose sole business is to attend them for this very purpose. They have two painters and draughtsmen, several volunteers who have a tolerable notion of Natural History; in short Solander assured

me this expedition would cost Mr Banks £10,000. All this is owing to you and your writings.'[23] The influence in those days of Linnaeus pervaded the entire scientific world, and Dr Solander was one of his favourite pupils, later becoming Banks's librarian. Fortunately, given the cramped conditions on board ship, Cook and Banks became staunch companions and firm friends.

Banks was just 26 years old when he left England, and by the time the *Endeavour* reached Tahiti the following year he was all too ready to succumb to the exotic charms which were freely offered by the native women, with the result that on his return his sexual exploits became a gift for gossip columnists and satirists. Patricia Fara writes that 'Botany may now seem a harmless scientific pursuit, but in the late 18th century it was fraught with sexual allusions. When satirists jeered at Banks for offering an exceptionally large plant to Queen Oberea they were not being particularly original... Throughout the Enlightenment period, lewd poems graphically compared women's bodies with geographical features such as hills, rivers and creeks, while plants provided pornographic analogies for the sexual organs of men and women.'[24] Queen Oberea had been generous with her favours to Banks and one cartoon of him, by Matthew Darly, bears the inscription:

I rove from Pole to Pole, you ask me why,
I tell you Truth, to catch a —Fly.

On his return, despite the gossip, Banks along with other heroes from Cook's epic voyage was summoned to Kew by the King. Their meeting was not only the beginning of a lasting friendship, but also 'the starting-point for a new Kew and for the economic prosperity of the Crown dependencies the world over'.[25] Banks recognized the importance of Kew as both a garden where plants from all over the world could

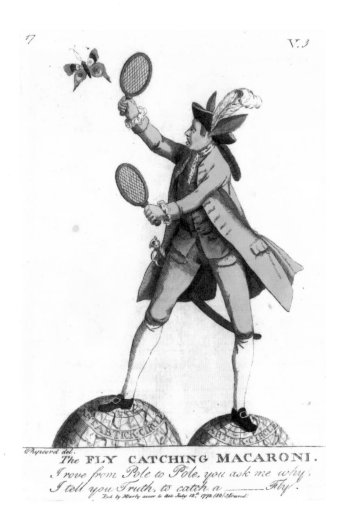

Matthew Darly, The Fly Catching Macaroni, *1772. Joseph Banks balanced on two globes attempts to catch a butterfly.*

be grown and an entrepôt – visualizing it as the 'great exchange house of the Empire, where possibilities of acclimatizing plants might be tested'.[26] It was Banks's vision, combined with his understanding of different climates, soils, etc., which led to Kew becoming the major plant resource of the world. In his capacity as Director he became responsible for sending botanists to different parts of the Empire, and he was insistent that they should not only note the properties of the various plants they discovered, but also record every detail of the environment in which they grew.

The sympathy between Banks and the King went beyond botany, as his biographer Hector Cameron noted: 'The friendship with King George III which Sir Joseph Banks enjoyed for nearly forty years, if it was begun in their common love of gardens and flowers, was cemented by the interest which they shared in the breeding of sheep.'[27] This is borne out by Banks's careful arrangements for the illicit export of a flock of Negretti sheep from Spain, which he divided on arrival in England, sending the ewes to Oatlands, the Duke of York's establishment at Weybridge, while the rams joined the royal flock at Kew. These were not the first sheep to graze there: in the previous decade Princess Augusta had desired her gardener Thomas Greening to supply a sufficient flock to feed the newly laid-out lawns – the Great Lawn as it came to be known – in front of the White House. Kew's ovine history is commented on in *Adam and Evelyn at Kew*, when describing the vicissitudes of the various bodies which had been responsible for administering the Botanic Gardens since they had come into the public domain: 'It is perhaps odd to think that acres which began as the famous exotic gardens of the Princess Augusta of Saxe-Coburg should for the last quarter of a century, have been under the control of the Ministry of Agriculture and Fisheries, but a slight connection may be found in the fact that George III imported to Kew, in 1791, a flock of Merino sheep.'[28] In 1781 Fulke Greville, the

King's Equerry, recorded a sheep sale 'in the great field not far from the Pagoda and fronting the road from Richmond to Kew. A Captain McArthur bought freely and he had at this time a valuable and numerous flock of sheep at Botany Bay.'[29] It was from this source, and with the active participation of Banks, that many of Australia's finest flocks were bred.

Although Banks could be tyrannical, he was a firm and devoted guardian of the interests of both the King and Kew, as can be seen from his defence of the head gardener, William Aiton, against the bullying of the King's friend the Marquis of Blandford, later fifth Duke of Marlborough. Blandford, who was to bankrupt himself through his profligate spending on his garden at Whiteknights in Berkshire, sent his gardener in a high-handed manner to Kew to collect some *Stapelia* cuttings and was deeply incensed at Aiton's rejection of the request. He wrote a hectoring letter to Banks, which ended: 'I must impose further on your goodness to order Mr Aiton to send them.' In a masterly response Banks replied: 'The King's orders to me were that your Lordship should have such plants from Kew Garden as you wanted and could properly be spared it is solely upon the interpretation of the word properly then that your Lordship and me can possibly differ I shall therefor take the liberty to define what in my opinion was His Majesty's meaning by that word in order that H.M.'s farther pleasure may be taken if I am wrong.' He went on to explain how important it was that Kew should always retain a sufficient number of plants of any one species to rule out the danger of loss, which is 'a matter which probably no one but myself is able to judge', concluding: 'Probably your Lordship will be satisfied that Mr Aiton could not with propriety suffer your Lordship's Gardiner to take cuttings from the Stapelias at his discretion indeed I have never encouraged the admission of Gentlemen's gardiners to act for themselves I have generally found these gentlemen little thankful for what they get and very clamourous for what is

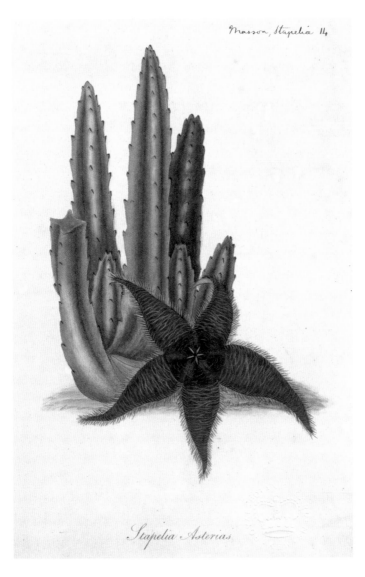

Masson, Stapelia 14

Stapelia Asterias

Francis Masson (1741–1805), Stapelia Asterias, *1796.*
Masson's only book, Stapeliae Novae, *on the South*
African succulents also known as 'carrion-flowers'
because of their smell, was published in 1796.

refused them.'[30] Banks may have been a little overprotective with regard to the *Stapelias*, 40 varieties of which had been brought back from the Cape by his protégé Francis Masson, the first of his botanical collectors, but Blandford was not the only one to complain of Banks's parsimony. The Reverend William Herbert, son of the first Earl of Carnarvon, noted that 'it was the narrow-minded doctrine of Sir J. Banks that he could only render the King's collection superior to others by monopolising its contents'[31] and the *Gardener's Magazine* noted how 'the rare plants were hoarded with the most niggard jealousy'.[32]

Banks was undoubtedly something of an autocrat, but he was also a loyal and staunch friend to those he perceived as forwarding the interests of botany and, along with the Swedish botanist Jonas Dryander and the artist Johan Zoffany, he was happy to act as one of the pallbearers at Aiton's funeral. As behoved his Scottish upbringing, Aiton was a Presbyterian, but he chose to be buried at St Anne's, Kew Green, as was Zoffany, who lived across the river at Strand-on-the-Green, and Thomas Gainsborough, who, although not a local, had expressed the desire to be buried close to his childhood friend Joshua Kirby. Through Bute's influence, Kirby had been appointed teacher of perspective to the Prince of Wales, who later, when king, made him and his son joint Clerks of Works at Richmond Lodge and Kew Palace. Both the King and Bute took advantage of Zoffany's proximity to commission portrait groups. In the early 1760s the latter commissioned an al fresco group of his three sons, including the future Bishop of Armagh, climbing trees and disporting themselves in a non-specific park-like setting probably based on Kew.

Frederick's mother, Queen Caroline, died in 1737, but her reprobate husband lived on for a further 23 years, and it took another 12 years after that before George III was able to buy the freehold of the White House, get an act of Parliament to

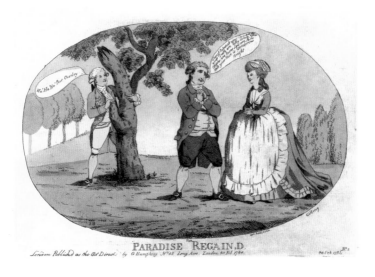

John Boyne, Paradise Regain'd, *1783. The Prince of Wales watches with amusement as Charles James Fox pays court to 'Perdita' Robinson.*

close Love Lane, and create the estate that we know today as Kew Gardens. During the early part of his reign the King and Queen spent a considerable amount of time at Kew, especially in the summer months, and when, with their ever-increasing brood, the White House became too crowded, the family overflowed into the Dutch House – or Kew Palace as it came to be called – as well as occupying various houses on Kew Green. The White House was demolished in 1802 as part of James Wyatt's abortive scheme to build a great new castellated palace for the King. From 1771 onwards, the Prince of Wales and his brother Prince Frederick had permanent apartments in Kew Palace, with the result that it became the setting for some of the future king's earliest excesses, not the least his budding affair with the actress 'Perdita' Robinson, to whom he gave a promissory note for £20,000 payable on his eighteenth birthday – 12 August 1780. By the time this anniversary came round he had already discarded her, passing her on to his friend Charles James Fox, the Whig politician and 'Man of the People', a liaison which provoked George Selwyn to ask: 'Who should the Man of the People live with, but the Woman of the People?'

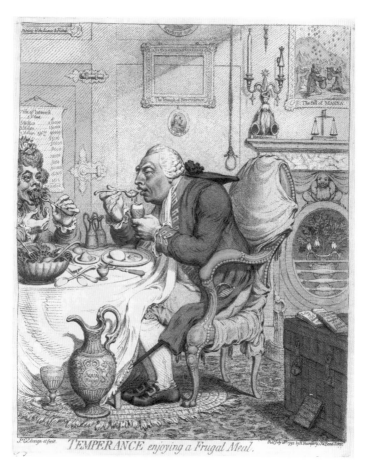

James Gillray, Temperance Enjoying a Frugal Meal, *1792. The King eats a boiled egg and the Queen a salad. All the accoutrements, from the empty frames to the strongbox, denote miserliness and parsimony.*

Much of the intimate life of both George II and George III and their families took place at Kew, with the Gardens providing a backdrop to dramas, tragedies and farces. It was to Kew that Joseph Banks conducted his exotic Tahitian, Omai – the 'Noble Savage' – to present him to the King, and it was here too that Fanny Burney, Second Keeper of the Robes to Queen Charlotte, had her famous encounter with the mad monarch. It was also here that the Duke of Cambridge was reputed to have seduced Lady Augusta Somerset. George III, in both sickness and health, liked to walk in the Gardens and he was often accompanied by John Little, Keeper of the Observatory, who was later hanged for murder; a similar fate was accorded to Dr William Dodd, the preacher at Queen Charlotte's Magdalen Hospital, but his crime was forgery. On the occasion that Fanny Burney unwittingly came in sight of the royal party, the King was accompanied by his medical attendant, Dr Willis, who feared that chance encounters might overexcite his patient and exacerbate his malady. 'To see him was not only forbidden, it was dangerous, and she fled off at speed, looking for somewhere to loose herself among the garden's "little labyrinths". To her horror, though, the King had spotted her and she could hear him in pursuit, calling out her name "loudly and hoarsely".' Unlike Evelyn in the film scene in *Adam and Evelyn at Kew*, the real-life Fanny did not fall into the pond but was detained by Dr Willis, who escorted her back to the royal presence, protesting that 'it hurts the King to run'. Instead of raving, the King embraced her and entered into a rambling conversation 'during which he sang bits of Handel in a croaking voice and became tearful remembering Mrs Delany'.*[33] The incident in fact triggered a remission in George's illness and four days later it was announced that 'The King is recovered from his late melancholy indisposition' and the Regency Bill, which was

* Mary Delany (1700–1788), a friend of the King and Queen, lived at Windsor and created plant portraits out of coloured papers.

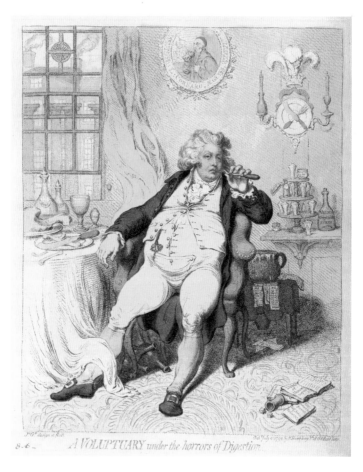

James Gillray, A Voluptuary under the Horrors of Digestion, *1792. The Prince of Wales surrounded by evidence of lavish living and unpaid bills. A stark contrast to his father's frugality.*

going through Parliament, was deferred, much to the chagrin of the Prince of Wales, his brother the Duke of York and their Whig friends.

The extended progeny of George III and Queen Charlotte, and their propensity for dissolute behaviour, was wittily lampooned by Peter Pindar:

Happy as birds, that with each other pair
And warble out their songs devoid of care:
So did these Princes, frolicsome and gay,
Pass free from spleen the jovial hours away.

At routs they shone, or blaz'd at grand reviews,
Held levées, talk'd of politics, and news,
But chiefly with the ladies shew'd their parts,
And made sad havoc 'mongst the female hearts.[34]

The princes, with the exception of the Duke of York, stood in strong contrast to their strait-laced and correct parents in their pursuit of pleasure, so it is no surprise that it was not always sweetness and light in the royal household. This was particularly true with regard to the icy relations between Queen Charlotte and her niece Princess Frederica, who as a 37-year-old widow had been engaged to the Duke of Cambridge before jilting him in favour of the obscure German Prince of Solms-Braunfels; widowed a second time, she caused even greater offence by marrying the Duke of Cambridge's elder brother, the Duke of Cumberland. Queen Charlotte, not surprisingly, refused to receive her, but Greville describes what he calls a 'contrived meeting' at Kew between the Duchesses of Cumberland and Cambridge. 'Jealousy, however, glinted a green eye. Her Grace of Cumberland was "seriously mortified" at the contrast between her reception and that of her sister-in-law. Her Grace, alas, was "by no means well looking." / How to make

peace between the Duchesses was now the problem. A meeting was arranged which "took place as if by accident but really by appointment in Kew Gardens." And the rivals "embraced." / The sequel was startling. So fierce was the "rage" of Queen Charlotte over the embrace of her daughters-in-law that she suffered "a severe spasm" and "was so ill on Friday evening that they expected she would die" – presumably of maternal affection.'[35]

Queen Charlotte did indeed die at Kew, but not on this occasion, nor of 'maternal affection', but of cancer, a few months after she had presided over the joint weddings of the Dukes of Clarence (the future King William IV) and Kent. By 1818, despite the fact that she and the King had had 15 children, there was no legitimate heir to the throne, the Prince Regent's only child, Princess Charlotte, having died in childbirth the previous year. Marriages were hastily arranged between the Duke of Clarence and Princess Adelaide of Saxe-Meiningen – a lady destined to be described by *The Times* 14 years later, at the height of the controversy over the Great Reform Bill, as a tawdry foreigner 'raised from obscurity to the highest pitch of glory'[36] – and the Duke of Kent and the Dowager Princess of Leiningen. The double ceremony, which took place in the Queen's drawing room at Kew Palace on 11 July 1818, was followed by a family tea party at the self-consciously rustic Queen's Cottage. Despite the fact that the King was, to all intents, dead to the world, it was a propitious day for the nation, as although both William and Adelaide's children died in infancy, the union between the Duke of Kent and the Dowager Princess resulted in the birth the following year of a daughter, Alexandrina Victoria, who succeeded to the throne as Queen Victoria on the death of her uncle in 1837.

Both George III and Sir Joseph Banks died in 1820, after which the Royal Botanic Gardens entered upon the two

darkest decades of their history. As monarch, George IV had little interest in the place except as a source of fruit, vegetables and flowers for his various establishments, though in his youth, as Thackeray tells us, the first we heard of him was 'warbling sentimental ditties under the walls of Kew Palace by the moonlight banks of Thames, with Lord Viscount Leporello keeping watch lest the music should be disturbed'.[37]

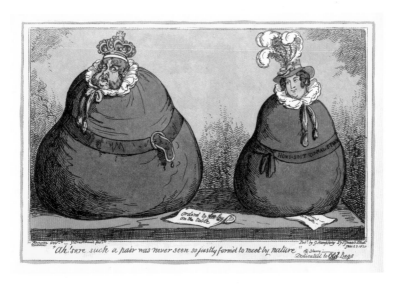

George Cruikshank, Old Sherry, *23 June 1820. King George IV and Queen Caroline satirized as huge green money-bags.*

Lord Malden was assigned a similar role a few years later as lookout during the Prince's assignations with the fair 'Perdita'. During the years of the Regency (1811–20), the Prince had become a self-indulgent voluptuary, and Greville dismissed those who praised him for his interest in the arts and for holding assemblies for the encouragement of literature, geography, astronomy and botany, commenting tartly: 'Astronomy, geography, and botany! Fiddlesticks! French ballet-dancers, French cooks, horse-jockeys, buffoons, procurers, tailors, boxers, fencing-masters, china, jewel, and gimcrack merchants – these were his real companions.'[38] Edward Bawden depicted the voluptuary

*Linocut of George IV for the Associated
Electrical Industries Ltd calendar, 1964.*

King, whose tailors' bills were reputed to be between £4,000 and £5,000 a year, in a brilliantly simplified linocut, with his well-coiffed locks descending in curves to chins, to folds of his stock and on down to the jewels and triple rank of insignia, including the Order of the Garter.

After George IV's death his successor, William IV, whom Greville described as a man with a head like a pineapple (a not unbefitting description for a man who had grown up at Kew), could often be seen riding in the Gardens. He liked the arboretum, authorized the removal of one of the Nash conservatories from Buckingham Palace and its re-erection at Kew, and approved Sir Jeffry Wyatville's design for the Temple of Military Fame, now known as King William's Temple, although he did not live to see its completion. He was a more sober monarch than his brother, but Greville describes him, prior to his accession, living a life of 'blameless irregularity' at Bushy with the actress Mrs Jordan and their nine children; continuing that up until this time he had lived in 'obscurity and neglect, in miserable poverty, surrounded by a numerous progeny of bastards, without consideration or friends, and he was ridiculous from his grotesque ways and little meddling curiosity. Nobody ever invited him into their house, or thought it necessary to honour him with any mark of attention or respect; and so he went on for about forty years... The death of the Duke of York [in 1827], which made him heir to the throne, his increased wealth and regular habits, had procured him more consideration, though not a great deal. Such was his position when George IV broke all at once, and after three months of expectation William finds himself King.'[39] Greville singularly failed to note that for at least part of the time he had lived equally obscurely not in Bushy but in Hanover with his wife, Princess Adelaide. A couple of years later Greville recorded: 'The Court [then ensconced at Brighton] very active, vulgar, and hospitable; King, Queen, Princes, Princesses, bastards, and attendants

constantly trotting in every direction.'⁴⁰ The Sailor King, as he was known, who had served as a young officer under Nelson and attended his wedding in the West Indies as witness and best man, died at Windsor on 20 June 1837 and was buried with due ceremony a few days later. Lord Melbourne delivered a funeral oration which 'was very effective because it was natural and hearty, and as warm as it could be without being exaggerated. He made the most of the virtues the King undoubtedly possessed, and passed lightly over his defects.'⁴¹

Linocut design of Queen Victoria for a ceramic panel in Victoria Underground Station, for the opening of the Victoria Line, 1969.

By the time Queen Victoria acceded to the throne, the Royal Botanic Gardens had become seriously neglected. Part of this neglect can be attributed to the younger Aiton's lengthy tenure (he had taken over from his father in 1793) and the steady accretion of responsibilities for the gardens at Buckingham Palace, Hampton Court and other royal residences which had inevitably diverted him from his principal job. With the multiplicity of demands, and with Banks's eagle eye no longer there, it is not surprising that standards had slipped except, as it appears, with regard to the dissemination of plants. Banks's parsimony in this department had become ingrained, much to the fury of a Mr

Burnard, who wrote to the *Gardener's Magazine* wondering why it had never occurred to the editor to 'notice the policy of Mr Aiton, the director of these gardens, with respect to the distribution of plants. Collectors of plants in general take a pleasure, and feel it to be their interest, when they have procured a rare plant, and propagated it, to distribute specimens among such friends as are likely to take care of it, and promote its increase in the country. I hardly know a single exception to this among private individuals, and is it not discreditable to the country that the only exception to this liberality should be found in the garden of the King?' He ended his letter with the damning observation that the system Aiton followed was 'that of a Dutch tulip fancier, who would rather destroy than give away'.[42]

Such complaints found ready outlets in the columns of the two most popular gardening magazines of the period, the *Gardener's Magazine* and the *Gardeners' Gazette*, the latter describing the condition of the Gardens shortly after William IV's death as 'slovenly, dirty and bug-infested', causing George Glenny, the editor, to declare that any man who had ever 'been taught the art and mystery of sweeping a crossing could suggest many useful hints, and keep the place in better order'.[43] Indeed, as Blunt says, the condition of Kew had by this time sunk so low that 'what Augusta and Bute had so lovingly created, what Banks had so skilfully nurtured, seemed about to decline into kitchen gardens to provide cabbages for Kings'.[44] The pressure thus generated in botanical circles provoked the Lords of the Treasury in 1838 into setting up a small working party under the chairmanship of John Lindley, Professor of Botany at University College, London, to 'inquire into the management, etc.' of the Royal Gardens. The other members of this very select committee were the Duke of Devonshire's head gardener, Joseph Paxton, later to achieve immortality as designer of the Crystal Palace, and John Wilson, gardener to the Earl of Surrey. It seems bizarre

that three such experienced men should have chosen the month of February for their formal inspection of Kew, especially as the winter of 1837–8 was particularly harsh. However, their conclusions were clear and concise: Kew should either be taken into state ownership and improved for the public benefit, or be abandoned altogether. The Lords of the Treasury sat on this report for some time before laying it before Parliament in May 1840, when the first of these options was adopted and responsibility for Kew was passed to the Office of Woods and Forests. The following year Aiton retired and Sir William Hooker was appointed Director.

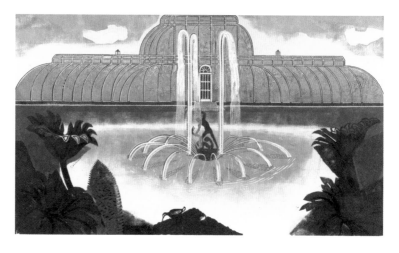

The Palm House, Kew, *linocut, 1963.*

As a young man Hooker had been a protégé of Banks, who had sent him to Iceland to make a complete botanical and geological survey of the island. The journey ended in near disaster when, on the return voyage, the ship caught fire; fortunately he and the crew escaped with their lives, but all the plants and specimens they had collected were lost. Hooker, one of the most distinguished botanists in Britain, had been Professor of Botany at Glasgow for the previous 20 years, along with his son, Joseph Dawson Hooker, who succeeded him as Director, resurrected the fortunes of Kew and, over the next 45 years, established it once again as the

world's pre-eminent botanical garden. One of the earliest manifestations of the mark that Sir William was to make on Kew was the commissioning in 1844 of the Palm House, a joint enterprise between the architect Decimus Burton and the Irish engineer Richard Turner. It took four years to build and quickly established itself, alongside the Pagoda, as one of Kew's most iconic and best-loved buildings. During the intervening years it has been threatened with demolition on several occasions due to structural problems. The most recent threat was in the mid-1950s, when plans were drawn up to replace it with a new structure incorporating the triumphal arches designed to span the Mall for the Queen's coronation.

Hooker initially faced an uphill task as Queen Victoria, prompted by her advisers, particularly her prime minister, Lord Melbourne – whose relationship to her was not so different from that of Lord Bute to her grandfather – wished to be rid of the expense and responsibility of the Gardens. Fortunately her attitude changed over time, especially when she learned from Banks's successor, Aylmer Bourke Lambert, of the interest that the Princess of Saxe-Coburg had taken in the Gardens. Despite the handover of the Gardens to the Office of Woods and Forests in 1841, Kew Palace and the Queen's Cottage remained Crown property, and it was not until the very end of Victoria's reign that she relinquished these: Cambridge Cottage and its gardens were ceded to Kew only after the death of the second Duke of Cambridge in 1904.

All George III's sons had had residences of their own at Kew. King's Cottage, 33 The Green, which had been built for Lord Bute to house his library and other reference material, had been given by the King in 1806 to his fifth son, the Duke of Cumberland. Many years later this elderly dyed-in-the-wool duke, by then King of Hanover, incensed by the perceived Whiggish tendencies of his niece and Prince Albert, and outraged by the Great Exhibition, wrote to his friend Lord

Strangford that 'even if I were in England I would not put a foot in Hyde Park, as I disapproved of the whole thing and I feared it would bring all the ruffians and *canaille* from all parts of the world into the country which might lead to very serious mischief, but instead I would remain quietly and enjoy the fine weather and the sweet scents of my little cottage at Kew'.[45]

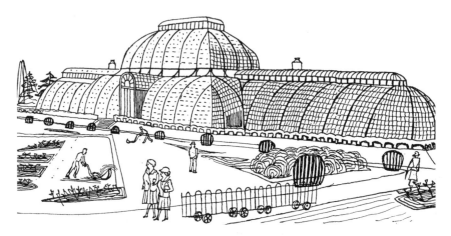

The Palm House, Kew, from The English Scene, *1953.*

ADAM & EVELYN
AT KEW

*Fragment of a letter from Elkin Mathews & Marrot
requesting a design for the spine for* Adam and
Evelyn at Kew, *with watercolour additions.*

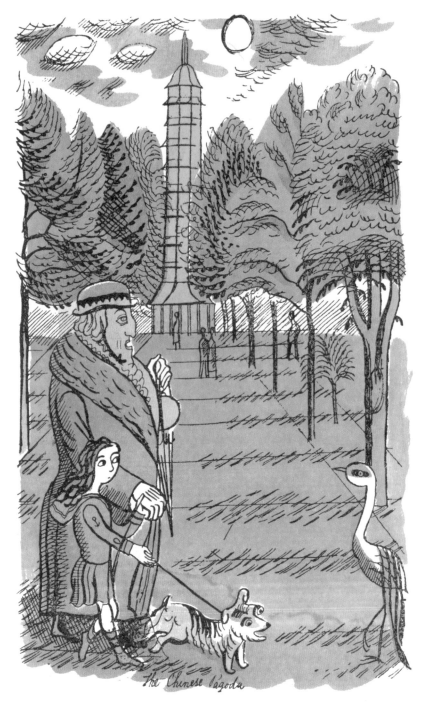

the Chinese Pagoda

*'Freeze, therefore, warping sky, and blow,
bitter wind, for this is spring in England.'*

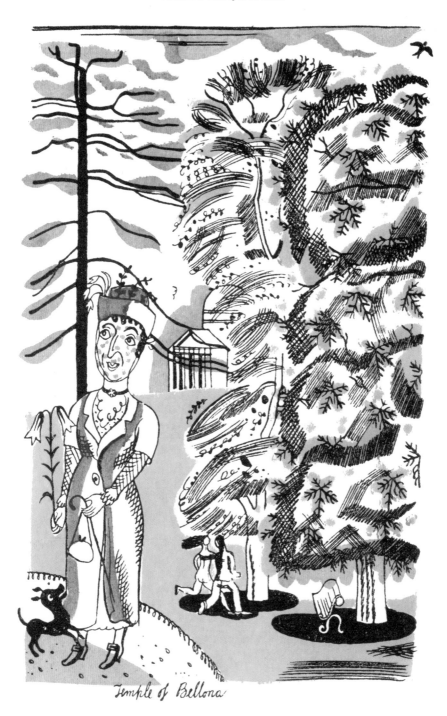

Temple of Bellona

'There was one crone Clorinda who would bring her dog in
a bag, and let it out when she thought no one was looking.'

'There she was, standing by him. Fresh from the pond, and without tresses to comb conveniently.'

Woodland Walk

'I told the car to be at the Main Gate, then
I'll have time for a little rest before dinner.'

*'She was ready when he came back,
unrecognisable in his holiday finery.'*

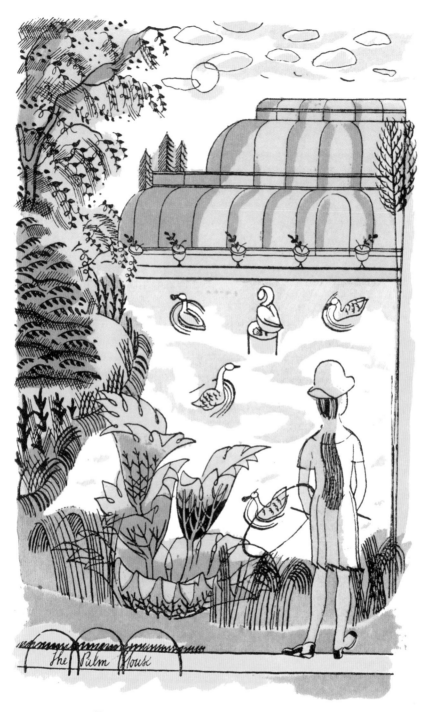

'He watched her, gazing at the Palm House, at its
high glass walls and the light hosing on them.'

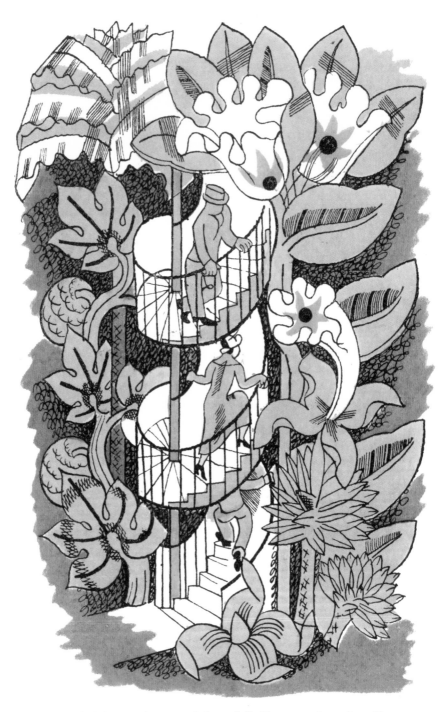

'*Evelyn liked the great leaves, and the tendrils. The steamy heat pleased her,*
but it reminded Adam of somewhere he had been before, he couldn't remember.'

Temple of Aeolus

'"He's a Guardian Angel of the Gardens," he explained to Evelyn,
as they hurried back to a little Temple to make a vow of goodness.'

Preparatory study for King William's Temple. *Bawden's illustrations in the printed book were reproduced as vibrant hand-stencilled watercolours.*

'*Now, look at these statues, they look as though they are having some terribly intimate disease, but if my nose was broken I think I should hold it instead.*'

'*Most of the people were chattering fools, who spent their time eating the buns they had brought and sat, back to the views, with their noses buried in bags and baskets.*'

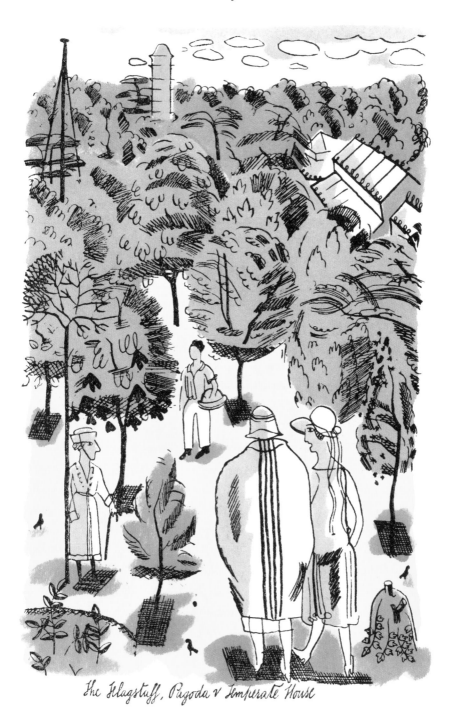

The Flagstaff, Pagoda v Temperate House

'So much was strange! If he could find out what it all meant,
he would know what each one of these mysteries was.'

85

Preparatory study for Kew Palace.

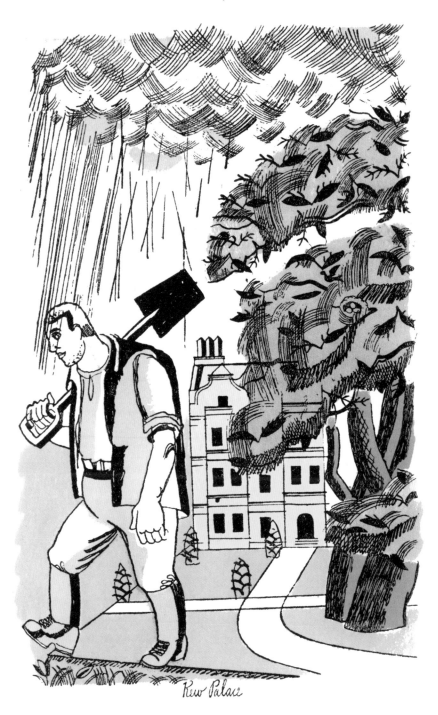

'For if there was a gardener in Eden, Kew is not without Adams.'

Squared-up study for The Orangery.

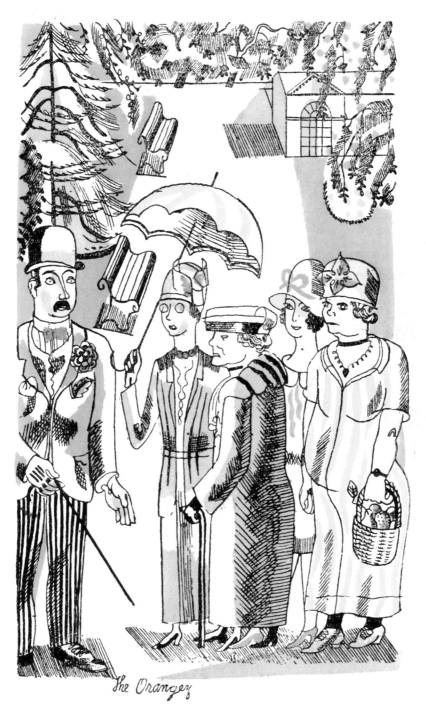

The Orangery

'There was a group of people by the orangery
wondering whether to turn back or go on.'

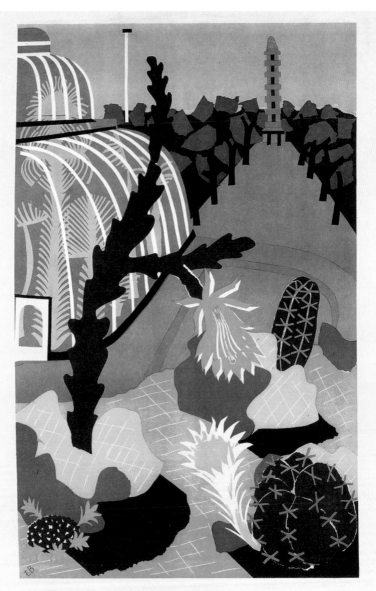

KEW GARDENS

Station: Kew Gardens
From Hammersmith Station: Bus 27 27[A] or
Trolleybus 655 667

Kew Gardens, *poster, London Transport, 1939.*

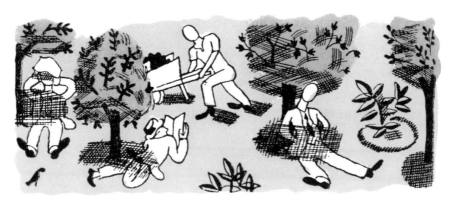

EDWARD BAWDEN & KEW

During the eighteenth and nineteenth centuries, when the Gardens were still largely a royal preserve, and before the railways had made public access relatively simple, surprisingly few artists of note, apart from Richard Wilson and the Sandbys, seem to have been attracted by Kew's artificial landscape. Happily, though, several topographical draughtsmen made accurate drawings and prints of the buildings, so we know more of the detail than of the *genius loci*. This started to change once they passed into the public domain and visitor numbers began to rise. In 1841, when the Commissioners of Woods and Forests first assumed responsibility, the annual attendance was 9,000, but by 1908, when the Underground Electric Railways produced the first Kew poster, visitor numbers had risen to 3 million. Kew Gardens and the London Zoo have since then inspired more London Transport posters than almost all other attractions put together, and given the fact that Frank Pick, the Board's Director of Publicity during the interwar years, was intent on selling the services of the Underground to as wide a public as possible, the choice of artists commissioned was eclectic. They include such well-known names as Edward Bawden, Maxwell Armfield, Clive Gardiner – Bawden's principal at Goldsmiths College – and Betty Swanwick, a student of both

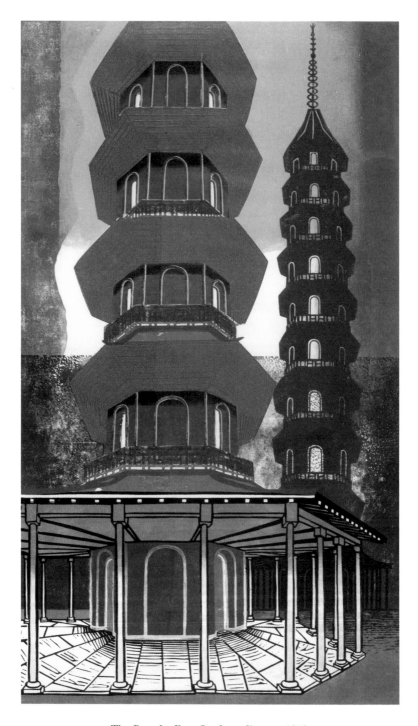

The Pagoda, Kew Gardens, *linocut, 1963.*

Gardiner and Bawden in the 1930s. In style they were equally broad in their appeal, ranging from Edward McKnight Kauffer's highly floral *Aster Time, Kew Gardens* (1920) and Frank Newbould's *The Cactus House, Kew* (1922), which was on the hoardings at the time Edward Bawden enrolled at the Royal College of Art, to Austin Cooper's severely geometric *Cheap Return Fare to Kew Gardens or Richmond* (1929). The image of Newbould's *Cactus House* poster must have lodged, consciously or unconsciously, in Bawden's memory as it certainly evoked an echo 17 years later when he designed his own Kew Gardens poster for the Underground, creating a collage of cacti, Palm House and Pagoda.

As a student at the Royal College Bawden was a single-minded and precocious young man, monosyllabic and widely read; he was a voracious devourer of popular ephemera, posters, book illustrations and the prints of J.E. Laboureur, as well as Edward Lear's humorous drawings and the watercolours of Francis Towne, John Sell Cotman and William Blake, though Blake had no direct influence upon his own work. London Transport posters were readily available, including the 1908 poster depicting the long tree-lined vista towards the Pagoda at Kew. In this simplified design, printed in green and yellow, the anonymous artist placed the Pagoda so that its pinnacle ran off the paper, thus decapitating it. It is hard to believe that Bawden remained unaware of this image, as he frequently repeated this compositional device, taking it to its utmost extreme in his well-known 1963 linocut of the Pagoda in which he placed a close-up of the lower four tiers of Chambers's building against a silhouette of the entire structure. Surprisingly, given the number of extant early sketches of the Pagoda in his scrapbooks and his later fascination with the image, its only appearance in his 1923 *General Guide* was in the map of the Gardens, though he selected other buildings for individual treatment. Perhaps at this early date he was more at ease with classical forms

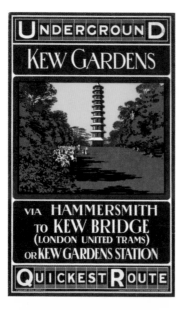
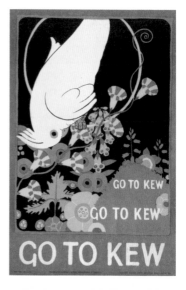
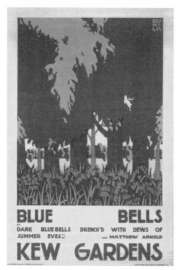
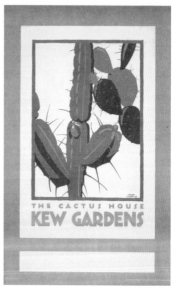

Kew Gardens posters for London Transport. Top left, *anonymous, 1908,* top right, *Maxwell Armfield, 1915,* bottom left, *Edward McKnight Kauffer, 1920,* bottom right, *Frank Newbould, 1922.*

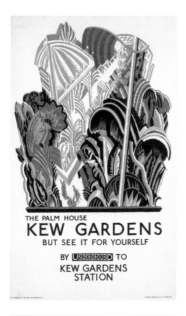
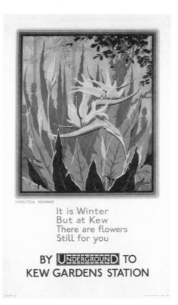
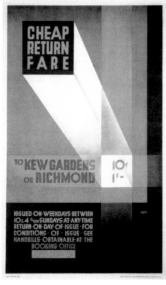
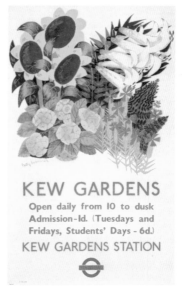

Kew Gardens posters for London Transport. Top left, *Clive Gardiner, 1926,* top right, *Wilfred Rene Wood, 1926,* bottom left, *Austin Cooper, 1929,* bottom right, *Betty Swanwick, 1937.*

and had not yet come to terms with Chinese baroque! The study of comparative architecture, a compulsory subject for students at the RCA during the 1920s, was taught by Professor Beresford Pite, whose Arts and Crafts credentials may have caused him to frown upon such architectural frivolity.

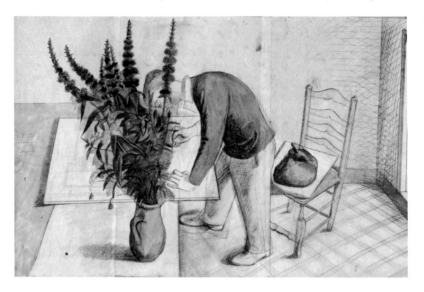

The Boy, Eric Ravilious in his Studio at Redcliffe Road, *watercolour, 1930.*

By the time Bawden came to London the London United Tram Service to Kew Bridge, as advertised in pre-war days, no longer existed, the Underground Group having absorbed the London General Omnibus Company and established a virtual monopoly over the city's transport system. From his student lodging house in Redcliffe Road, on the borders of Kensington and Fulham, and later from the adjacent Holbein Studios, where he drew his friend Eric Ravilious half-concealed behind a large vase of flowers, he would have followed the instruction on Gardiner's and other posters to reach Kew Gardens 'By Underground to Kew Gardens Station'. During his first six months at the Royal College of Art he must have made that journey on numerous occasions, particularly at weekends, in order to prospect the ground and prepare the studies which he incorporated into *A General*

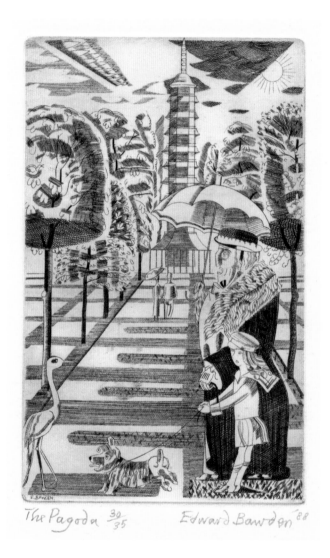

The Pagoda, *copper engraving, 1927–9, reprinted as part of a complete collection of Bawden's copper engravings in 1988.*

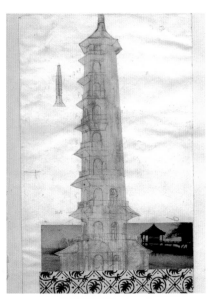

Studies at Kew, c.1922–3, pasted into Bawden's scrapbooks.

Guide to the Royal Botanic Gardens Kew, Spring & Easter 1923. Aside from the generalized vignettes, this delightful juvenile work contains well-observed and carefully drawn studies of Kew Palace, the Temple of Aeolus, the Palm House and William IV's Temple. Vignettes such as the ones of George III and Queen Charlotte at tea and Sir William Chambers directing the building of the Orangery required little more than general research, while those of the attendants and gardeners, and the clerks enjoying a bank holiday treat, are pure invention. However, the maps, particularly that of Kew Green, reveal a detailed knowledge which could only have been obtained by careful personal observation. In order to achieve the effect he sought in this plan, he adopted a bird's-eye vantage point, thus flattening out the area in the manner of seventeenth-century cartographers and reorientating the buildings where necessary in order to show their façades. To achieve this required a degree of simplification and abstraction to make the design fit the page. Walking round the Green today, 90 years later, with this map in hand, is to marvel at Bawden's inventiveness and attention to detail. Despite the necessity for constriction, many buildings are still identifiable, such as the Coach and Horses, Abingdon House on the corner of Ferry Lane, the Herbarium House and, on the south side, Lord Bute's former library, the Duke of Cambridge's residence with its classical *porte-cochère* and the two Dutch-gabled cottages which had only been built a few years previously.

Bawden produced his dummy guide in the traditional manner, using upside-down print to indicate areas reserved for text. In such circumstances most artist-designers resort to whatever newsprint is to hand, but Bawden selected extracts from the British Museum's guide to the permanent exhibition of books from the King's Library.[1] At this distance in time, and without documentary evidence, it is impossible to know whether his choice of text was pure serendipity or

whether he was making a subtle connection between Kew and King George III's library; it would have been totally in character for him to make such a link, and he would have derived quiet amusement from wondering whether anyone else would ever make the connection.

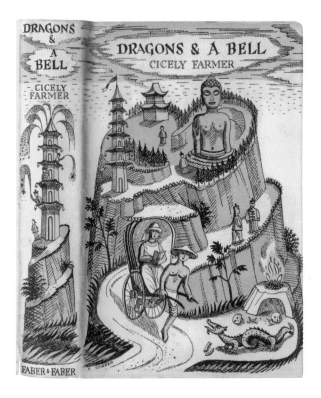

Dust jacket for Dragons and a Bell *by Cicely Farmer, 1931.*

He gave the manuscript – now in the Higgins Art Gallery and Museum, Bedford – to Eric Ravilious and inscribed it 'my first book'. Although he was barely 20 years old when he produced *A General Guide* it gives us a foretaste of his future work. Precocious beyond his years, Bawden knew precisely what he intended to do; his vision was already formed and only his skills required further refinement.

The *General Guide* contains intimations of much of his future commercial work, advertisements, book jackets and

illustrations, particularly those for *Adam and Evelyn at Kew*, *Dragons and a Bell* and Ambrose Heath's many cookery books, especially *Good Food* and *More Good Food*. The manuscript booklets he drew a quarter of a century later to amuse his children – published in 1963 under the collected title of *Hold Fast by Your Teeth* – also had their genesis in his Kew experiences.

Chapter heading for May, Good Food, *1932. Thomas Hennell seated near left next to Eric Ravilious, with Edward Bawden and Tirzah Ravilious opposite.*

One of these little books, *Don't be Led by the Nose*, is a cautionary tale about a gentle worm whose string of names – James Augustus Adolphus William – could almost have been gathered from among the Hanoverian princes. With his love of the macabre and esoteric, Bawden would surely have been aware of that far from gentle worm the cannibalistic *Bipalium kewense*, whose Latin name derives from the Gardens where it was first identified. Equally at this period he must have visited the glasshouse devoted to filmy ferns and become familiar with polypods, both of which were to be resurrected in animate form in *Lady Filmy Fern, or the*

Voyage of the Window Box, a 1930s fireside *divertissement* enlivened by witty drawings which was finally published in 1980, complete with a text by Thomas Hennell.

There can be no doubt that *Adam and Evelyn at Kew* is the book whose illustrations derive most directly from the *General Guide*. *Adam and Evelyn*, now a highly desirable collector's piece, is a strange little book with an almost unreadable text by Robert Herring, an aspiring Imagist author, playwright and associate of Richard Aldington, who earned his living as film critic of the *Manchester Guardian*. Herring had some practical experience of films, having played the role of a very camp pianist in a 1930 silent Imagist film, *Borderline*, made by Kenneth Macpherson and featuring several other members of Ezra Pound's circle, including Bryher and HD.* Aficionados apart, the film is memorable today to a wider audience only for the fact that it provided the vehicle for the debut performance of the young Paul Robeson. It is not, however, Herring's text but Bawden's illustrations that make *Adam and Evelyn at Kew* such a desirable object, so it is important to consider the book in some detail.

Adam and Evelyn at Kew or Revolt in the Gardens, to give it its full title, was published in 1930 under the imprint of Elkin Mathews & Marrot. In striving for the Imagist ideal of clarity, Herring's text, which hovers self-consciously between fantasy and dream, begins by introducing the hero of the title:

* Bryher was the pen name of Annie Winifred Ellerman (1894–1983), who financed the making of *Borderline*. HD was Hilda Doolittle (1886–1961), an American Imagist poet and author.

For if there was a gardener in Eden, Kew is not without Adams, suffering in much the same way, sinning inevitably, each of them treading the same paths and following the same routine [...] apart from gardeners being less interesting than a gardener (enough being, as Eve discovered after only one bite of the apple, as good as a feast), it needs no great strain to discover in any one Adam – in the one chosen for this tale, for instance... the counterpart of his fellows.

The action of the story, such as it is, takes place on a single spring-like day in March when a film company is making one of the earliest talking films to be shot on location in England. Writing shortly after the Wall Street Crash and at a unique moment in cinema history, Herring uses his technical knowledge to make fun of hidden microphones, as well as mocking the domination of the industry by Austro-Hungarian directors. In a drowsy state induced by the unseasonably warm sunshine, Adam confuses elderly ladies in flowered dresses with flowerbeds.

The ladies had often looked like flower-beds, but that they should be flower-beds was quite exceptional. There before his eyes they merged, swayed; hung and merged. There had never been a bed on that lawn, he knew, so it must be a lady: but then, there never had been a lady (he was sure) quite so efflorescent, so it must be a flower-bed... unless it could all be explained by saying he had sunstroke.

The film being made is loosely based on George III's life – 60 years before *The Madness of King George* – and the heroine, Evelyn, is the actress playing the role of Fanny Burney, who in her rush to avoid an encounter with the mad King has fallen into the pond. Having retreated into the bushes and shed her wet costume, she emerges Eve-like, 'without tresses

to comb conveniently', to ask Adam for a loan of his apron in order that she can go and retrieve her own clothes. As it is past midday Adam is, for some unlikely reason, off-duty, so he too goes to change into his holiday finery, and when they meet up again Evelyn attempts to explain the plot:

> '*You see, the Director* [who has not been English for very long] *has the grand idea of making something quite new in record time. A great historical film of Kew. He didn't know much about Kew or its history himself, but he knew it had never been done. Besides, with all the foreign actors we'd had to take over in some of our recent agreements, a film of English history was the only way we could use them when talkies arrived.*'

During the Depression many actors were out of work, while others were trying to come to terms with having to speak, something they had never previously had to do, let alone in English! As Evelyn says:

> '*It's one thing to win a film contract in some hair-dye competition, but quite another to find you are expected to speak* English. *Most of us never had to. We just talked when necessary, and that was all; now we have to enunciate* [...] *God certainly expressed His views on democracy when he thought of Babel, and even Fritz Lang couldn't improve on it.*'

It is this thin story which provides the context for Bawden's delightful illustrations, several of which were worked up from drawings conceived seven years earlier to decorate the *General Guide*. A comparison between the two versions is instructive as it shows clearly how far he had travelled in the intervening years; this is especially true in comparing the 1923 frontispiece of a pair of young Cockneys on a bank holiday spree with its later counterpart. Although the two

figures retain much the same stance, they have been miraculously transformed into Adam and Evelyn, their body language totally different as they stride confidently through the Gardens. His new self-assurance and stylishness can be seen in the drawing of the schoolgirl gazing across the pond to the Palm House: her hair has grown fashionably long, her hat and dress have acquired a fresh jauntiness and even the ducks and coots have become more skittish. Shy as he was, Bawden had used his student years and the period when he and Eric Ravilious were working on murals for Morley College to hone his powers of observation, with the result that his work, while retaining its individuality, had become naturally more sophisticated. He had developed from a tyro into that animal that John Ward so eloquently described as 'the bird watcher of men', noting their nesting and mating habits and recording them with a clear, Gothic line.[2] A style that was to become recognizable to thousands during the ensuing decades through book jackets, posters and, above all, the series of advertisements for Shell with their punning captions, such as *Too Much Hadham or Shell over Whelmed, Stow-on-the-Wold but Shell on the Road* and *Gardeners End but Shell goes on for ever*, devised by John Betjeman.

Comparing the two depictions of Kew Palace is equally instructive, especially as a rapid preliminary sketch for the later version survives. The fussy drawing of the brickwork in the earlier image has been replaced by a far more effective simple pink wash, while the introduction of the old tree – complete with bird's nest and eggs – and the curving path gives the whole design a sense of depth. Although Bawden's eye still retained its earlier innocence, by 1930 his grasp of composition was assured; he was totally in control of his

STOW-
ON-THE-WOLD

but

SHELL
ON THE ROAD

YOU CAN BE SURE OF SHELL

Press advertisement for Shell, c.1932.

medium and free to indulge in the visual games that reflected his own very idiosyncratic sense of humour, as is evident from the endpapers of *Adam and Evelyn*. The earlier maps, charming as they are, are niggly in detail, but when he came to redraw them he jettisoned both detail and scale in the interest of overall design, as giant amarylises, arums and salas overflow from the Gardens with abandonment onto Kew Green. This quality of exuberance dominates his drawing of the interior of Decimus Burton's Temperate House, in which plants embrace the spiral staircase – as in reality they do – but those single-eyed predatory flowers are a Bawden fantasy, perfectly illustrating Herring's text in which 'the canary creepers that covered the spiral with their flattened branches were truly giving out an odour of chloroform' as Adam and Eve climbed the stair, pushing aside the lazy tendrils and leaves.

Bawden was never one to waste a good image and if he revamped some from his *General Guide* for *Adam and Evelyn* others were totally fresh, though two – *The Chinese Pagoda* and *The Flagstaff, Pagoda and Temperate House* – relate closely to a pair of line-engravings he had recently made in his quest to master the craft of commercial line-engraving and to explore the visual effect of an incised rather than drawn line. Bawden was not alone in his interest in earlier, semi-redundant printing techniques – John Piper revived the art of aquatint for his Brighton series – and it was this that prompted him to go to the Sir John Cass Institute, where such skills were still taught by a trade-engraver who specialized in lettering; the subject continued to interest Bawden, who had originally enrolled as a calligrapher in the Design School at the Royal College of Art. It was this fascination, combined with his quirky sense of humour, which made him the ideal in-house artist for the Curwen Press, where, during the late 1920s, he worked one day a week. Harold Curwen, who had studied printing in Leipzig,

adapted the Arts and Crafts ideals of William Morris, Emery Walker and others to the twentieth century, moving away from the hand-press and helping to develop and improve new automated techniques, particularly offset lithography. He delighted in printing illustrated broadsheets, pamphlets, trade cards, chap-books, etc. such as *The Spirit of Joy*, inspired by his favourite artist, Claud Lovat Fraser.

The Bibliolaters Relaxed, *menu design for the Double Crown Club dinner, 16 February 1928.*

Fraser had died prematurely young in the aftermath of the Great War, but his example was kept alive by his many admirers, including Paul Nash, who passed on his enthusiasm to Bawden, Eric Ravilious, Enid Marx and others of his students at the Royal College of Art. Although Bawden's style was very different from Fraser's, he was, nevertheless, able to capture the same 'spirit of joy' and turn it to good use in such youthful *esprits* as *The Bibliolaters Relaxed* for the February 1928 menu of the Double Crown Club – a dining club for people involved with fine printing, founded in the

'Lily O'Grady, Silly and shady, Longing to be, A lazy lady'. Illustration to Popular Song, *from* Façade, *by Edith Sitwell, set to music by William Walton. Ariel Poem No.15, published by Faber & Gwyer, 1928.*

1920s by Curwen's partner Oliver Simon, which still continues today – and his illustration to Edith Sitwell's Ariel Poem *Popular Song*, both printed at the Curwen Press.

Bawden's delight in Kew was not merely visual; he developed an abiding interest in plants and gardening, an interest that took practical form after his marriage to Charlotte Epton in 1932, when his father bought Brick House at Great Bardfield for them. Bawden and Eric Ravilious had previously rented part of the house as a base for landscape painting, and Edward and Charlotte invited the Raviliouses to continue to share it for a while. As a wedding present, Eric designed and built a trelliswork gazebo for the back garden, while other friends gave them plants and advice. Bawden's scrapbooks contain many letters – or more frequently parts of letters – from Charles Mahoney, Evelyn Dunbar, John Nash and others concerning garden-related matters. One letter from Herbert Walden, the local contractor at nearby Shalford, written in November 1934, concerns delivery of red gravel for the paths, which must have been a second consignment as a pile of red gravel is clearly visible in Ravilious's watercolour *The Garden Path*, painted the previous winter.[3]

By the early 1930s Bawden had clearly established a reputation among his plant-loving friends as being something of an authority, and in February 1934 he wrote to his former Royal College friend Cecilia Dunbar Kilburn, asking whether she would be interested in writing a book about gardening. 'Fabers are publishing in addition to "Good Food" & "More Good Food" other books relating to Good-ness in food & drink, & I suggested to them the ultimate necessity for giving in the series a book on gardening to assist the epicure who grows his own vegetables, saladings, herbs & seasonings.'[4] Ambrose Heath, in the Foreword to *Good Food*, described his objectives as being to show that good cooking could be easy and need not be expensive: expanding on this, Bawden

suggested to Kilburn that the proposed gardening book should be personal, discriminating and informative and should have 'no ultimate aim except aesthetic discernment & the enjoyment of good form'.[5]

Eric Ravilious, The Garden Path *(Brick House), watercolour, 1933.*

A few weeks later he sent her a copy of William Cobbett's *The English Gardener* and a long, somewhat rambling letter outlining his ideas for the book, which he envisaged having four sections. The first would be largely historical, treating the relationship between house and garden; what he termed 'the planning & disposal of gardens' was a subject to which he reverted several times. 'Should the vegetables, herbs & "architectural" plants be segregated in special enclosures, and thus not form any portion of the garden proper, that is to say of the garden immediately surrounding the house?' He was also exercised over the distinction – and therefore their location – between plants that yielded 'cut' flowers and those that don't. The second section would be on 'saladings, herbs & seasonings'; the third on plants 'ornamental, noble, strange, curious & wonderful' – surely an echo here of John Nash's

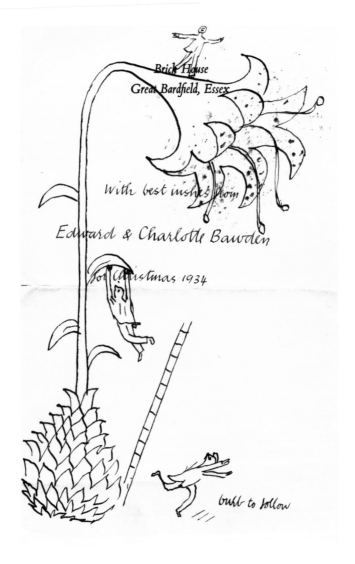

Brick House
Great Bardfield, Essex

With best wishes from

Edward & Charlotte Bawden

for Christmas 1934

bulb to follow

Turk's Cap Lilly, *for Cecilia Dunbar Kilburn, Christmas 1934.*

Poisonous Plants: Deadly, Dangerous and Suspect, proofs of which he had sent him seven years previously. The fourth and final section was to be reserved for general remarks: 'The introduction would propound the question of garden in relation to modern building & the fourth section would form the answer. Is'nt [*sic*] it all very simple?'[6] Not surprisingly, Kilburn did not regard the matter as outlined as being at all simple and spent much time perusing the works of J.C. Loudoun and other historical texts, as well as Marie-Luise Gothein's recently translated *History of Garden Art*, which she regarded as her ultimate bible. Inspired by the latter, she became fascinated with early records, particularly the accounts of Pliny's garden, as well as various antiquarian speculations concerning the design of the Garden of Eden, little, if any, of which was helpful in advancing the proposed publication.

During April and May a flurry of correspondence kept the project alive, with long letters from Kilburn concerning such esoteric subjects as to whether Pliny had used acanthus instead of grass for a lawn, and suggesting that if the section on salads and herbs was overlong 'it would smell rather too strongly of Beverley Nichols'.[7] However, by the autumn Bawden's interest had clearly cooled and Kilburn's six-page letters had reduced to rather terse notes: 'May your funkias breed slugs and your aliums ooze earwigs.'[8] 'What about the drawings? Have you started doing them?'[9] And a few weeks later, somewhat petulantly, in response to an evasive letter of explanation: 'Your letter does not mollify me in the least.'[10] The demise of this project did not affect their friendship and at Christmas Bawden sent her a drawing of a lily, following it up a few weeks later with 'a bulb of Lilium Chalcedonium, the scarlet Turk's Cap Lilly, which I promised you at Christmas. If it is at all like the drawing I sent you then I shall be very surprised, but in its own way I hope it will be equally magnificent.'[11]

Artists' interest in plants and botany in England has seldom been as intense as it was during the interwar years, with the possible exception of the eighteenth century. The aftermath of the Great War and increasing threat of further strife created a bond between man and the soil, that deep love that Rupert Brooke had eulogized in 'The Soldier':

> *A dust whom England bore, shaped, made aware,*
> *Gave, once, her flowers to love, her ways to roam,*
> *A body of England's, breathing English air,*
> *Washed by the rivers, blest by suns of home.*

This, combined with increasing industrialization and the rapid erosion of the countryside, created a wave of nostalgia resulting in the publication of new, often illustrated, editions of the works of earlier English nature writers, such as William Cobbett, Richard Jefferies, Francis Kilvert and Gilbert White, whose *Natural History of Selborne* Eric Ravilious illustrated for the Nonesuch Press. William Cobbett, a self-confessed lover of beautiful gardens, worked for a short period at Kew in the 1770s, recording many years later that 'the present King and two of his brothers laughed at the oddness of my dress, while I was sweeping the grass plot round the foot of the Pagoda'.[12] Cobbett's *English Gardener*, of which Bawden had sent a copy to Cecilia Kilburn, had been published in 1837 and to celebrate its centenary Noel Carrington at *Country Life* issued *The Gardener's Diary 1937*, decorated by Edward Bawden, in which he reprinted some of Cobbett's inimitable weekly reminders, such as that for 'March in the Flower Garden': '*Sow* adonis, alyssum, prince's feather, snap-dragons, yellow balsam, candytuft, catchfly, etc. *Plant* autumnal bulbs such as tiger flower, dahlias, anemones, ranunculuses, if any not yet planted, may take a late blossom. Hardy kinds of potted plants that have been sheltered should be now gradually inured to the open air, dress auriculas, carnations, protect best tulips and

hyacinths, plant off-sets and part fibrous-rooted plants, take up and plant layers of carnations, pinks, seedlings of the same and other things and plant them, plant box, thrift and daisies for edgings.'

The Gardener's Diary, *Country Life, 1937.*

Noel Carrington struck a revealingly twentieth-century note when he wrote: 'In introducing this little diary to the public for the first time a word or two may be said concerning the use to which it is hoped it will be put. It is known that some will be kept mint-clean of all entries and stood in the shelves of connoisseurs and bibliophiles. This, alas, is the fate of many copies of any book to-day in which an artist and publisher put themselves to any pains. That has been the fate of many of those Kynoch Press Note Books on which I must

admit the present volume is modelled.' Lamenting such preciosity, he continued: 'Neither editor nor artist would be shocked if fingers which were not devoid of mother-earth hastened to make entries.'

Bawden borrowed back from Kilburn such drawings as he had done for their abortive project in order to show them to Carrington, and rather embarrassingly had recycled a number of them for *The Gardener's Diary* without her permission, prompting a retrospective request: 'Do you remember the plant drawings of mine which I borrowed to show Noel Carrington of Country Life? I wonder if you would mind these drawings being reproduced in a C.L. publication called the Gardener's Diary? I was commissioned to do 52 drawings, one for each week of the year, but I broke down at the thirty-sixth or seventh effort & had recourse to pad out the remaining blanks with these other drawings. I asked Carrington to sue for permission for use of your property, but I find he has done nothing about it.'[15] Bawden was clearly suffering from pressure of work at the time, designing posters for London Transport, designs for Barrow's Stores, book jackets and his superb linocut *Cattle Market, Braintree*, which, after adaptation, was published by Contemporary Lithographs Ltd, along with examples by Paul Nash, Barnett Freedman and Eric Ravilious, as part of the Lithographs for Schools series.

In addition to having to pad out his drawings for *The Gardener's Diary*, he also failed to meet the deadline for his promised introduction to Evelyn Dunbar and Charles Mahoney's book *Gardeners' Choice* (George Routledge and Sons Ltd, 1937), but in an extant draft he pointed out that the plants Dunbar and Mahoney had selected had been influenced by two criteria: one was that they were reasonably easy to cultivate; the other, more importantly, was that the artists were 'primarily interested in the appearance of a plant as an

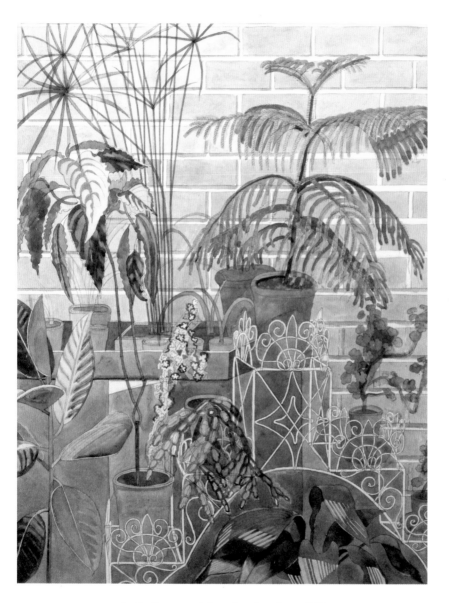

Jardinière, *pen, ink and watercolour, 1979.*

end in itself'. It was the 'habit of the plant, the form, colour, texture of the leaf, stem, shoot, bud and seed pod or fruit' which attracted Dunbar and Mahoney and defined the choice of their 40 favourite perennials.[14] Bawden could just as easily have been writing about himself and his own approach to plants. Perhaps he was. He was conservative in his approach and cautious about the introduction of new and untried species. 'The framework of vegetative life in the garden must be supplied by trustworthy shrubs and herbaceous plants of whose ability to form backgrounds, screens, hedges, covered walks and specimen groups we have had evidence.'[15] His analysis of plant forms was idiosyncratic. His attention 'to the appearance of a plant as an end in itself' is clearly evident in his linocut *Campions & Columbine* in its several different printings and his 1979 watercolour *Jardinière*, with its assemblage of Christmas cacti, succulents and ferns, while his analysis of plants and trees in a landscape, whether in watercolour or linocut, differed from his approach when treating them as primary subjects. In his landscapes, with their emphasis on overall design, he developed a personal shorthand which, while suppressing naturalistic detail, was capable of transmitting the requisite factual information to the viewer. This is particularly noticeable in his 1963 linocut *Lindsell Church*, where the yew tree and lilac in the churchyard, despite being reduced to near-abstract patterns, retain their essence and individuality.

John Nash, another close friend, whose elder brother, Paul, had taught Bawden at the Royal College, was as committed a plantsman as Mahoney and Dunbar, not only exchanging plants but also sending Bawden proofs of his 1927 wood engravings for *Poisonous Plants: Deadly, Dangerous and Suspect*, a book dedicated to Clarence Elliott, the renowned nurseryman from Six Hills at Stevenage, who shared Nash's other passion – fishing. In the 'Dangerous' category Nash included *Helleborus foetidus* or stinking hellebore, which

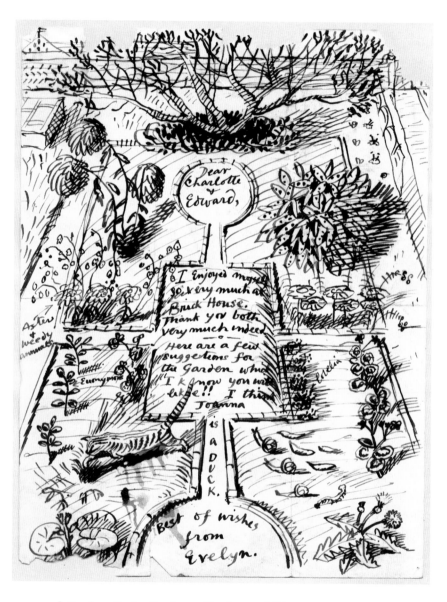

Letter from Evelyn Dunbar to Charlotte and Edward Bawden, 1935.

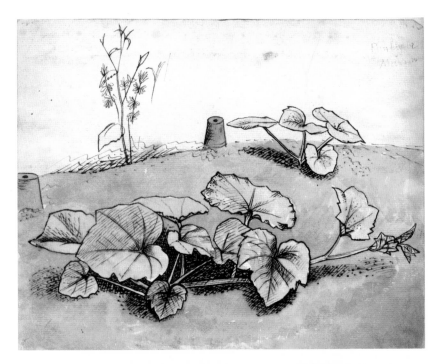

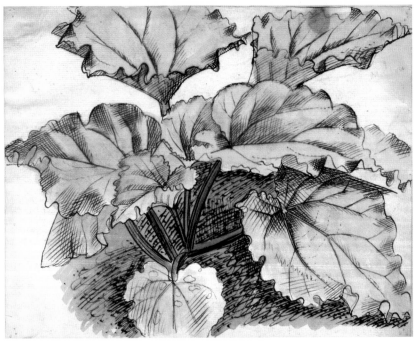

Pumpkin (top) and Rhubarb (bottom), from Bawden's scrapbooks.

would have had lasting appeal to Bawden, who prided himself on the multiple varieties of hellebores he cultivated at Brick House. The accompanying quote from *Gerard's Herbal* of 1633 would also have appealed to his sense of humour: 'The leaves of the bastard Hellebore dried in an oven, after the bread is drawne out, and the powder thereof taken in a figge or raisin, or strawed upon a piece of bread with honey, and eaten killeth wormes in children exceedingly.' Bawden wrote to Mahoney in May 1934, telling him that he had just 'acquired 3 hellebores. H. viridus, H. foetidus, and one I cannot exactly place but which may correspond with H. cyclophyllis. Perhaps I will write to J[ohn] N[ash] & ask his opinion. The hellebores at Kew are as numerous as they are confusing.'[16]

A few days later, after spending a day at Kew, Kilburn wrote to Bawden asking if he knew *Euphorbia epithymoides*, adding: 'I think John Nash would love it [...] Another plant I noted as being lovely now is Rogersia Purdomii. So far it is only showing a leaf like a thick and reddish horse chestnut leaf on a very hairy stem about 1½ to 2 foot high. I don't know what it does next, but at the moment it is simply crying out for you to do its portrait. You will find it in the Rock Garden near the stream bed.'[17]

A record of the exchange of plants and seeds between Bawden, Nash and their other artist friends would add a whole new dimension to the story of botanical art in the twentieth century. In praising Bawden as 'the most punctilious sort of good gardener' who always sent the plants he promised,[18] Nash seemed to imply that others of their friends were less so, or perhaps sent the wrong things. However, this 'gentle nest of artists' – Bawden, Nash, Evelyn Dunbar, Mahoney, Kilburn, Cedric Morris and others – shared the view of Mr Burnard, the *Gardener's Magazine* correspondent already quoted, that collectors of plants enjoy distributing specimens among such friends as are likely to take care of them.

Kew acted like a magnet, drawing Bawden back decade after decade, with the occasional diversion for London Transport to St James's Park, Knole, Knebworth, Downe or Bushy Park, where he celebrated Chestnut Sunday. Sixteen thousand copies of the beautifully simple window bill he designed to advertise this event in 1936 were printed by the Curwen Press, which the same year also printed his Kew Gardens poster with its design of ducks, chrysanthemums and the Pagoda. He was to return again to the Pagoda and Palm House, but in the meantime, in preparation for the coronation, he collaborated with the Garter King of Arms in adapting the heraldry for the Queen's Beasts for the New Elizabethan Age, bringing to them, as Sir George Bellew said: 'a touch of the desirable quaintness and charm associated with the heraldry of the middle ages'. These 10 stone figures with their heraldic devices, carved by James Woodford, RA, which had stood proudly at the entrance annexe to Westminster Abbey, are now ranged along the terrace in front of the Palm House.[19] Surprisingly, they do not appear in Bawden's grand 1963 *Palm House* linocut, but the fountain group by Joseph Bosio of *Hercules Wrestling with Achelous in the Guise of a Snake*, a recent gift to Kew from the Queen, creates a central motif for this otherwise overextended composition. Bosio's sculpture had been exhibited at the Paris Salon in 1824 and acquired by George IV, who installed it on the East Terrace at Windsor Castle, where it remained until donated to Kew.

A noticeable difference between Bawden's three direct views looking across the pond to the Palm House is that in his 1923 depiction the only flowers to be seen are primroses and a cowslip; by 1930 the gunneras that grow in front of Burton's museum building have sprung up, and by the time he made

the linocut in 1963 they act as an exuberant baroque frame for the composition in contrast to the severe symmetry of the Palm House. Bawden loved painting and drawing large-leaved 'architectural' plants and used to pay regular visits to a friend at Heligan in Cornwall, where he delighted in depicting the tree ferns and giant gunneras, the only drawback being the spikes on the underside of their leaves which from time to time would descend like darts onto his bald pate.

He made two further rather austere Kew images towards the end of his life, *Kew Palace* and *The Queen's Garden*, which were produced as lithographs and printed at the Curwen Studio in 1983. The Dutch House, as Kew Palace was originally known, had been built in 1631 for the merchant Samuel Fortrey, long before there was any royal connection with Kew; George III, as we have seen, rented it as an overflow residence for the young princes before acquiring the freehold, which Queen Victoria only relinquished in 1896, with the stipulation that the room in which Queen Charlotte had died should be preserved intact. Following her death, Queen Charlotte had lain in state for a day in the King's Dining Room so that staff and friends could pay their last respects. The following morning the funeral cortège, with the Queen's hearse drawn by eight horses with black velvet coverings and ostrich plumes, left the Palace for St George's Chapel, Windsor, bringing to a close the most vital years of Kew as a royal residence. The choice of the King's Dining Room for the lying in state had been a practical one, as it enabled the mourners to enter the Palace by the front door, pass through the house and leave by the steps into the garden.

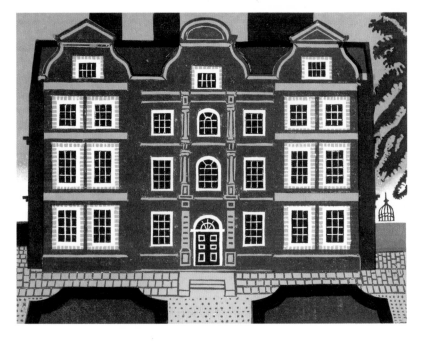

Kew Palace, *lithograph from linocut, 1983.*

The layout of the garden as depicted by Bawden in his final image in 1983 was not as it had been in Queen Charlotte's day but a recent creation devised by Sir George Taylor, Director of the Gardens from 1956 to 1971. At the time of the bicentenary, when the Queen and Prince Philip made their official visit, it is recorded that the Prince looked out of a back window at the Palace and was appalled by the sight of 'semi-derelict allotments and trees surmounting a tip formed of ash from the glasshouse boilers'.[20] His comments can be imagined. Spurred on by the Prince, and with funds from an Australian benefactor, Taylor created what was deemed to be a perfect Stuart garden, with a geometric parterre and clipped box hedges, appropriate to the date of the house. This garden was formally opened by Queen Elizabeth II, Queen Charlotte's great-great-great-great-great-granddaughter, in May 1969.

Bawden's love affair with Kew, as we have seen, stretched over six decades, from 1923 to 1983. In one of his earliest

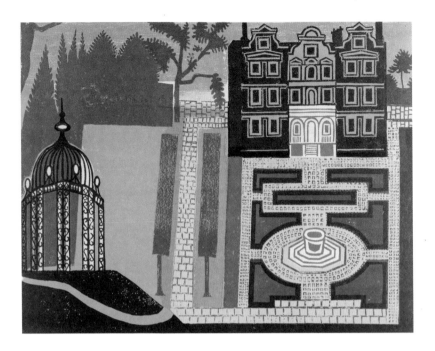

The Queen's Garden, *lithograph from linocut, 1983.*

drawings, the proto-Adam walks past the front of Kew Palace, little changed from when Philip Mercier had painted Prince Frederick and his sisters making music in front of it two centuries earlier, so it is perhaps fitting that his final image should have been of the garden through which the loyal mourners departed, having paid their respects to Queen Charlotte, Frederick and Augusta's daughter-in-law, one of Kew's most devoted royal patrons.

NOTES

HISTORIC KEW

1 *Gardener's Magazine* (10 April 1875), Vol.18, p.166.

2 Letter from Edward Bawden to John Nash, written from Dunwich, dated 20 April 1948, Tate Archive 8910.1.2.40.

3 Ray Desmond, *The History of the Royal Botanic Gardens Kew* (London, 2007), p.212.

4 Wilfrid Blunt, *In for a Penny* (London, 1978), p.22.

5 Ibid., p.1.

6 *Royal Magazine* (March 1765), pp.114–15, quoted ibid., p.4.

7 William Thackeray, *The Four Georges* (London, 1866), p.64.

8 Ibid., p.69.

9 The Hon. Mrs E. Stuart Wortley (ed.), *A Prime Minister and His Son* (London, 1925), p.18.

10 Quoted in John Harris and Michael Snodin (eds), *Sir William Chambers: Architect to George III* (New Haven and London, 1996), p.57.

11 Thackeray (cited in note 7), p.133.

12 Edward Pearce, *The Great Man* (London, 2007), p.377.

13 Wortley (cited in note 9), p.50.

14 Karl Wolfgang Schweizer, 'John Stuart Bute', *Oxford Dictionary of National Biography*, www.oxforddnb.com.

15 Harris and Snodin (cited in note 10), p.4.

16 Quoted in Blunt (cited in note 4), p.32.

17 John Harris, 'Sir William Chambers and Kew Gardens', Harris and Snodin (cited in note 10), p.67.

18 See Blunt (cited in note 4), Foreword.

19 Harris and Snodin (cited in note 10), p.58.

20 *Gardener's Magazine* (18 April 1916), Vol.59, p.163.

21 Harris and Snodin (cited in note 10), p.65.

22 W.J. Bean, *The Royal Botanic Gardens, Kew* (London, 1908), p.13.

23 Quoted in H.C. Cameron, *Sir Joseph Banks, KB., PRS.: The Autocrat of the Philosophers* (London, 1952), pp.15–16.

24 Patricia Fara, *Sex, Botany & Empire* (Cambridge and Crows Nest, Australia, 2003), p.11.

25 Mea Allan, *The Hookers of Kew* (London, 1967), p.36.

26 Quoted ibid.

27 Cameron (cited in note 23), p.200.

28 Robert Herring, *Adam and Evelyn at Kew* (London, 1930), pp.9–10.

29 Frank McKno Bladon (ed.), *The Diaries of Colonel the Hon. Robert Fulke Greville, Equerry to His Majesty King George III* (London, 1930), p.73.

30 Quoted in Cameron (cited in note 23), pp.80–81.

31 Quoted by Blunt (cited in note 4), p.71.

32 *Gardener's Magazine* (1837), Vol.13, p.469.

33 Claire Harman, *Fanny Burney* (London, 2000), p.219.

34 Quoted in Roger Fulford, *Royal Dukes* (London, 1973), Foreword.

35 Philip Whitwell Wilson (ed.), *The Greville Diary* (London, 1927), Vol.1, p.92.

36 See Antonia Fraser, *Perilous Question: The Drama of the Great Reform Bill 1832* (London, 2013), p.228.

37 Thackeray (cited in note 7), p.182.

38 Ibid., p.179.

39 Wilson (cited in note 35), Vol.2, p.260, diary entry for 16 July 1830.

40 Ibid., p.523, diary entry for 14 December 1832.

41 Ibid., p.560, diary entry for 25 June 1837.

42 *Gardener's Magazine* (May 1827), Vol.2, pp.313–15.

43 *Gardeners' Gazette* (October 1837).

44 Blunt (cited in note 4), p.75.

45 Quoted in Fulford (cited in note 34), p.249.

EDWARD BAWDEN & KEW

1 I am indebted to Nicolas Barker for this identification.

2 John Ward, *World of Interiors*, July 1992, reprinted in *Tribute to Edward Bawden*, The Fine Art Society (London, 1992).

3 Letter dated 14 November 1934, Scrapbook B, p.55.

4 Undated letter, envelope postmarked 24 February 1934, Tate Archive 8424.7.

5 Ibid.

6 Letter dated 8 April 1934, Tate Archive 8424.8.

7 Letter dated 13 April 1934, Tate Archive 8424.27.

8 Letter dated 19 September 1934, Scrapbook C, p.157.

9 Letter dated 1 October 1934, Scrapbook B, p.18.

10 Letter dated 25 October 1934, Scrapbook B, p.56.

11 Letter dated 18 January 1935, Tate Archive 8424.16.

12 *Cobbett's Weekly Political Register*, 19 February 1820.

13 Undated letter, Tate Archive 8424.22.

14 Gill Clarke, *Evelyn Dunbar: War and Country* (Bristol, 2006), p.60.

15 I am indebted to Gill Clarke for this previously unpublished extract.

16 Undated letter, envelope postmarked 2 May 1934, private collection.

17 Letter dated 12 May 1934, Tate Archive 8424.36.

18 Scrapbook A, p.146.

19 H. Stanford London, *The Queen's Beasts* (London, 1953).

20 Ray Desmond, *The History of the Royal Botanic Gardens Kew* (London, 2007), p.285.

PICTURE CREDITS

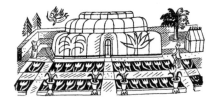

Edward Bawden's Scrapbooks, 73, 98, 119, 120

Andrew Edmunds, 39, 43, 49, 54, 59, 60, 62, 65

The Higgins Art Gallery, Bedford, 10–32, 50

Private Collections, 8, 52, 66, 68, 70, 72, 82, 86, 88, 92, 97,
100, 101, 106, 108, 109, 115, 124, 125

Reproduced with the kind permission of the Director and
Board of Trustees, Royal Botanic Gardens, Kew, 44, 57

Sworders Fine Art Auctioneers, 117

Tate Archive, 112

TfL from the London Transport Museum Collection,
90, 94, 95

Towner Art Gallery, Eastbourne, 96, 111

Victoria and Albert Museum, 2, 3, 5, 6, 7, 33, 36, 37, 74–81,
83–5, 87, 89, 91

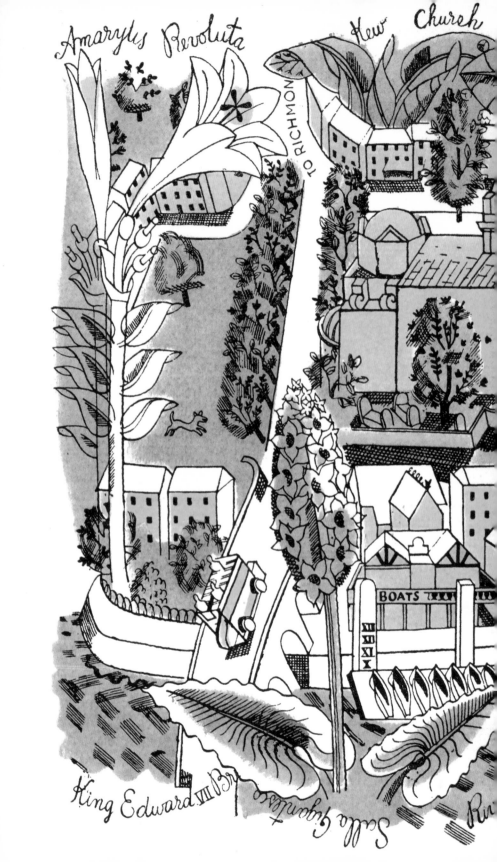